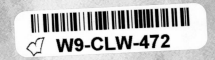

Digital Portrait Photography
of Teens and Seniors

SHOOTING AND SELLING TECHNIQUES FOR PHOTOGRAPHERS

PATRICK RICE

AMHERST MEDIA, INC. ■ BUFFALO, NY

Published by:
Amherst Media®
P.O. Box 586
Buffalo, N.Y. 14226
Fax: 716-874-4508
www.AmherstMedia.com

Publisher: Craig Alesse
Senior Editor/Production Manager: Michelle Grant
Assistant Editor: Barbara A. Lynch-Johnt

ISBN: 1-58428-162-6
Library of Congress Control Number: 2004113078
Printed in Korea.
10 9 8 7 6 5 4 3 2 1

Notice of Disclaimer: The information contained in this book is based on the author's experience and opinions. The author and publisher will not be held liable for the use or misuse of the information in this book.

Contents

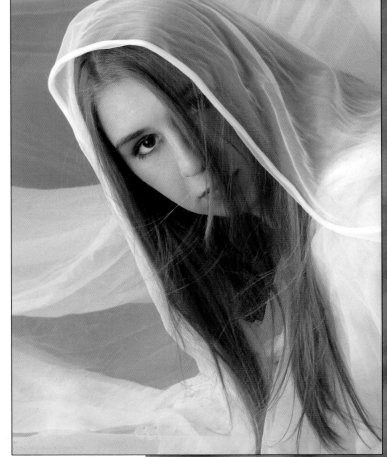
Image by Kathryn Sommers.

3

Image by Patrick Rice.

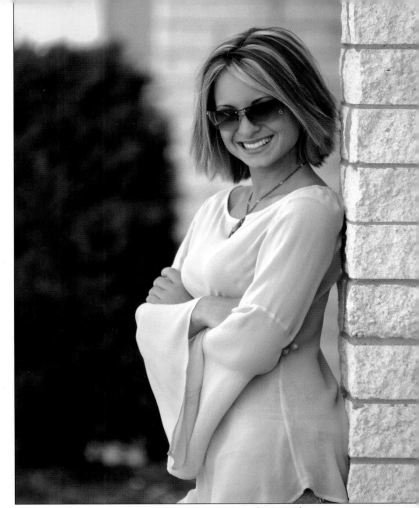

Image by Scott Gloger.

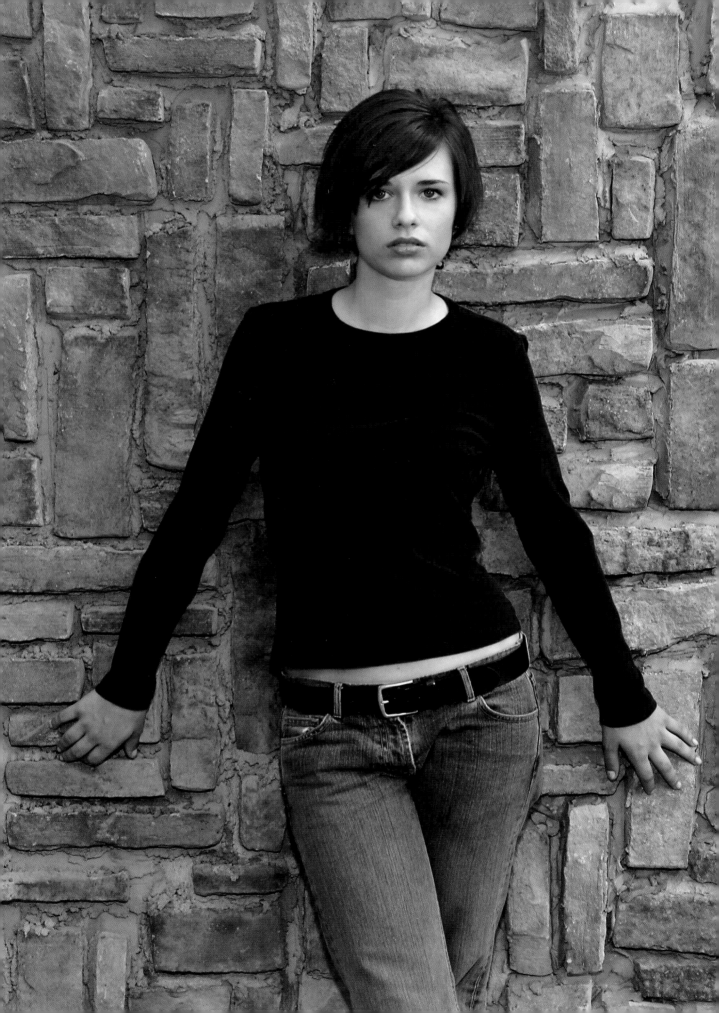

About the Author

Patrick Rice of North Olmsted, Ohio, has been a professional photographer for more than twenty-six years. He holds a Bachelor of Science degree from Cleveland State University, the Professional Photographers of America (PPA) Master of Photography and Photographic Craftsman degrees, as well as all five levels of the Wedding and Portrait Photographers International (WPPI) Masters degree. He holds the designation of Certified Professional Photographer from PPA and the Professional Photographers of Ohio (PPO) and has received the Advanced Award Medallion from the Ohio Certified Professional Photographers Commission. He is also the recipient of the Fellowship Award from the Photographic Art Specialists of Ohio (PASO) and Service Award Medallion from the Society of Northern Ohio Professional Photographers (SONOPP). Patrick has received countless Best of Show honors and has also been included in the PPA Loan Collection and PPO's Ohio Top Ten. He has been named Photographer of the Year by SONOPP five times and twice by the Akron Society of Professional Photographers (ASPP). In 2000, Patrick received the Honorary Accolade of Lifetime Photographic Excellence from WPPI. In addition, he was selected to receive the Photography Leadership Award from the International Photographic Council at the United Nations in New York City. He is an active member of Senior Photographers International (SPI).

Patrick has lectured and judged extensively throughout the United States and Canada. He has presented programs at both the PPA and WPPI annual photography conventions. His work has been published in several photographic magazines, and he is the author of *Infrared Wedding Photography* (2000), *The Professional Photographer's Guide to Success in Print Competition* (2003), *Professional Digital Imaging for Wedding and Portrait Photographers* (2004), *Digital Infrared Photography* (2005), and *Professional Techniques for Black & White Digital Photography* (2005), all published by Amherst Media.

Facing Page— Today's teens and seniors like images that stand out. Here, the portrait has a certain edge that appeals to many students. Image by Patrick Rice.

Contributors

Michael Ayers—The recipient of two Master of Photography degrees and the United Nations Leadership Award, Michael has made a career of giving back to the photographic industry. He has invented album designs and construction concepts, authored countless articles and books, and has lectured to more than 25,000 photographers worldwide. To view samples of Michael's work, visit his website at www.TheAyers.com.

Mark Bohland—Mark is a professional photographer from Mansfield, Ohio. He has earned his Certified Professional Photographer and Photographic Craftsman degrees from PPA and is only a couple of merits from receiving his Master of Photography degree from PPA. His award-winning images have been included in the PPA Loan Collection.

Scott Gloger—Scott has been a photographer nearly his whole life. His father, Myron Gloger, started his first studio in the 1950s, so Scott was always around photography. Since taking over the helm at Myron Photographic Excellence in Beechwood, Ohio, Scott's work has earned numerous awards—including the Fuji Masterpiece Award. Scott was also named Retoucher of the Year by the Photographic Art Specialists of Ohio. He has earned the Photographic Craftsman and Certified Professional Photographer degrees from PPA. His service to the profession includes being elected president of the Akron Society of Professional Photographers and serving on the board of trustees of PPO.

Bernard Gratz—Bernard owns and operates Portraits by Bernard in Dover, Ohio. A professional photographer for over thirty years, he holds the Photographic Craftsman degree from PPA and has served many years as an elected councillor to that association. Bernard is a past president of the Akron Society of Professional Photographers, has served on PPO's board of trustees for more than twenty years, and is a past chairman of PPO.

Jeff and Kathleen Hawkins—Jeff has been a professional photographer for over twenty years. In addition to serving as the public relations director of the Wedding Professionals of Central Florida and on the board of directors of the Professional Photographers Society of Central Florida, Jeff has won numerous awards in national print competitions. He is a popular lecturer on marketing and digital photography.

Kathleen is the author of *The Bride's Guide to Wedding Photography* (Amherst Media, 2003) and *Digital Photography for Children's and Family Portraiture* (Amherst Media, 2003). In addition to overseeing the operation of Jeff Hawkins Photography, she conducts private consultations and leads workshops at photo conventions worldwide, educating photographers on the products and services need-

ed to create a successful business and heirloom products for their clients.

Jeff and Kathleen are coauthors of *Professional Marketing & Selling Techniques for Wedding Photographers* (2001) and *Professional Techniques for Digital Wedding Photography* (2004), both from Amherst Media.

Leonard Hill—Leonard is an award-winning professional photographer from Zanesville, Ohio. He is actively involved in both the PPO and the Professional Photographers of Central Ohio. In addition to his photographic artistry, Leonard is an expert at website design; he designed the website for PPO and those of numerous professional photographers.

Ken Holida—Ken is a professional portrait and wedding photographer from Willard, Ohio. He holds the designation of Certified Professional Photographer from both the PPO and PPA. He also holds the Master of Photography degree from PPA. Ken is very active in professional associations; he serves as a PPA Council Delegate from Ohio and is a past president of PPO.

Robert Kunesh—Robert is an art teacher, photographer, and co-owner of Studio K Photography and SKP Photo Lab in Willoughby, Ohio. Since receiving his first merit print in 1997, he has accumulated forty-five additional merits in PPA's film and digital competition categories. Seven of his images have been chosen for the PPA Loan Collection, and four have been placed in the PPA Showcase book. He has also earned a Kodak Gallery Award, a Fuji Masterpiece Award, three Court of Honor Awards, and well over a hundred accolades since joining WPPI in 1998.

Michelle Perkins—Michelle is a professional writer and digital photo retoucher specializing in wedding, portrait, and architectural imaging. She has written for *PC Photo* and *Rangefinder* and is the author of *Traditional Photographic Effects with Adobe® Photoshop®* (2nd ed., 2004), *Beginner's Guide to Adobe® Photoshop®* (2nd ed., 2004), *Color Correction and Enhancement with Adobe® Photoshop®* (2004), *Beginner's Guide to Adobe® Photoshop® Elements®* (2004), *The Practical Guide to Digital Imaging* (2005), and *Digital Landscape Photography Step by Step* (2005), all available from Amherst Media.

Barbara Rice—Barbara has had an extensive professional photography career that has allowed her to work for studios in four states in the past twenty-six years. She received her formal photographic education from the Rhode Island School of Photography and has gone on to earn numerous professional degrees, including PPA's Master of Photography and Photographic Craftsman degrees. In addition, she holds the Accolade of Lifetime Photographic Excellence and Honorary Accolade of Lifetime Photographic Excellence Degrees from WPPI. Barbara has received numerous awards in WPPI print competitions and had the highest-scoring print in the entire 1998 WPPI Award of Excellence Competition—a score of 99! Her creative wedding albums have received the Fuji Masterpiece Award, and one was accepted into the PPA Loan Collection. Barbara is a coauthor of *Infrared Wedding Photography* (Amherst Media, 2000).

Lisa Smith—Lisa is an award-winning photographer and studio owner from San Diego, California. She is a member of the Digital Art Guild, San Diego; the La Jolla Art Association; PPA; and WPPI; and her photographs have appeared in numerous photography publications. For more information, visit her at her website at www.lisasmithstudios.com.

Kathryn "Sunshine" Sommers—Kathryn has owned and operated Sunshine Photography in Middletown, Ohio since 1983. She was one of the first three photographers in the world to be awarded the Master of Photography degree from PPA in less than three years. She is also a Certified Professional Photographer and holds a degree in photographic technology in portraiture from the prestigious Ohio Institute of Photography. She has had many images included in the PPA Loan Collection and Showcase books and has won numerous local, state, national, and international competitions. She has been named among the Ohio Top Ten Photographers and has won many Special Image Awards. She has also won the coveted Kodak Gallery Award. Sunshine is a member of the honored American Society of Pho-

tographers, and her images are displayed throughout homes globally, thanks to her ability to capture the "heart and soul" of her clients.

Scott M. Tallyn—Scott is one of the industry's leading instructors. For more than a decade, he has helped photographers worldwide to create better images. Scott holds the Master of Photography and Photographic Craftsman degrees from PPA and is a popular lecturer. His company, Tallyn's Professional Photographic Supply of Peoria, Inc., is one of the leading suppliers of photo-related products in the nation.

Chad Tsoufiou—Chad is one of the brightest young stars in the field. With over ten years' experience taking pictures, his talents have matured quickly. His formal training in photography began at Lake High School in Hartsville, Ohio. From there, Chad went on to study photography at Kent State University, from which he graduated with a degree in photo illustration. He's won many awards for his photography through the years and has worked as a portrait and commercial photographer. Working both as the primary and secondary (documentary) photographer at Rice Photography, Chad has developed a unique ability to capture the emotions of the wedding day.

Dennis Valentine—Dennis is a professional studio owner from Louisville, Ohio who has over twenty years' experience. His images have won numerous awards in local, state, and national competitions. He is a Certified Professional Photographer from PPO and is an active member of both PPO and the Akron Society of Professional Photographers.

Visualizations Photography, Inc.—In May of 1999, a dream became a reality for Aaron and Joanna Patterson: they opened Visualizations Photography, Inc. The main focus of the business was portrait photography. They enjoyed working with people—capturing the expressions and moments that would last a lifetime. In May of 2002, Visualizations was lucky enough to hire a recent graduate from Kent State University, Amanda Masciarelli-Flavelle. Her high energy and personality were a welcome addition to the studio. In May of 2003, another Kent State grad, Ashley Trainer, joined the creative team at Visualizations Photography Inc. Her keen eye for fashion and her ability to relate with the youth were benefits to the studio. Together, these four photographers have grown Visualizations to one of the largest all-digital portrait studios in the state of Ohio. Focusing on the client is the studio's number-one priority. These photographers always work for the client's best expression in a fun and upbeat way. They are all certified photographers through the state of Ohio and are constantly challenging themselves with national and regional print competitions. The creative team is driven and has the desire to be the number-one choice for portrait photography.

James Williams—James is a professional photographer from Champion, Ohio with over twenty years' experience. He has earned the designation of Certified Professional Photographer from both PPA and PPO. In addition, James is the recipient of the Accolade of Photographic Mastery degree from WPPI. He is active in several photographic associations and has served as president of SONOPP.

Robert Williams—Robert runs Robert Williams Photography in Tallmadge, Ohio. His portrait and wedding images have won several awards in local, state, and national competitions. He holds a Master of Photography degree from PPA. He has also earned the Certified Professional Photographer degree and Advanced Award Medallion from PPO. Robert is a past chairman of the Ohio Certified Professional Photographers Commission and a past president of PPO.

Monte Zucker—Monte is a world-famous photographer who has received every award the industry offers. In 2003, the United Nations honored him as Portrait Photographer of the Year. He has also received WPPI's Lifetime Achievement Award. He feels that his most special honor is the fact that his popularity with photographers of all ages is continually growing.

Introduction

Teen and high-school senior photography is both one of the most profitable and most competitive areas of professional photography. However, it is important to understand that different ideas may work well in one market and not at all in another. I will attempt to share the many marketing ideas that I have used or am aware of. In addition, the technical aspects of the text should give every photographer a clear understanding of how digital imaging will enhance their teen and high-school senior photography business.

For our studio, the process of becoming a successful senior photography business has been the most challenging endeavor of my professional career. We are constantly learning and trying new ideas. Not everything has worked for us. We have spent thousands of dollars on promotions. We network with noncompetitive senior portrait photographers and share ideas. Many of the policies that we have implemented at our studio are those that other photographers have shared with us. Throughout this text, I will credit the photographers and studios from which we may have first heard about a particular promotion or idea. This does not imply that a given individual was the photographer who originated a specific idea in the senior photography industry—it's just that they were the ones who shared the information with us. In special sections called "Pro Tips" you'll find advice from some top-ranking professionals in the field. We have tried many, but not all, of the many different ideas included in this book. My intention is to provide as much information as possible and let you choose what will work best for you.

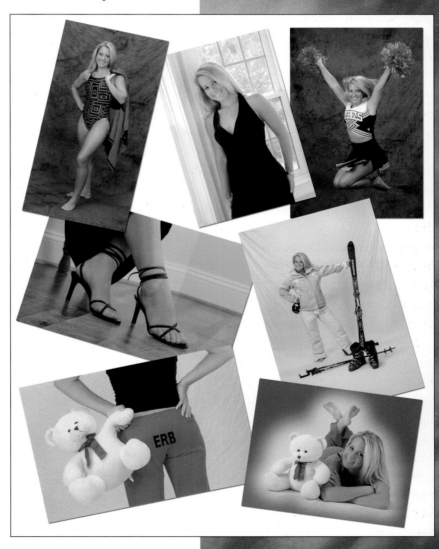

Photos like these capture many facets of a teen's personality. Composite image by Michael Ayers.

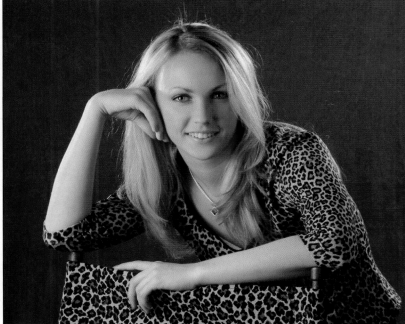

*Facing Page—Today's teen and senior images are a far cry from the traditionally posed, cookie-cutter portraits of the past. Image by Ken Holida. **Above Left and Right**—Texture and pattern can be used to add interest in your photos. Images by Dennis Valentine.*

Our business is in a western suburb of Cleveland, Ohio. In Ohio, binding school contracts are still legal. We do not have any high-school senior or underclass contracts. However, there are two very large studios, each with several such contracts. These companies easily outspend all of the other photogra-phy studios in Cleveland. We have found that we had to be more creative in our marketing pieces in order to have an impact on the market. We have had to offer advantages to the seniors the big contract pho-tographers wouldn't or couldn't provide. We have a keen awareness of what these studios and other pho-tographers in our area are sending out to the stu-dents. We have been able to find some "chinks in the armor" and capitalize on them. I don't feel any one idea is going to dramatically change your profitabili-ty in teen and high-school senior photography. Rather, you will become more profitable by incorpo-rating several ideas and tracking each to see which are the most successful for your studio.

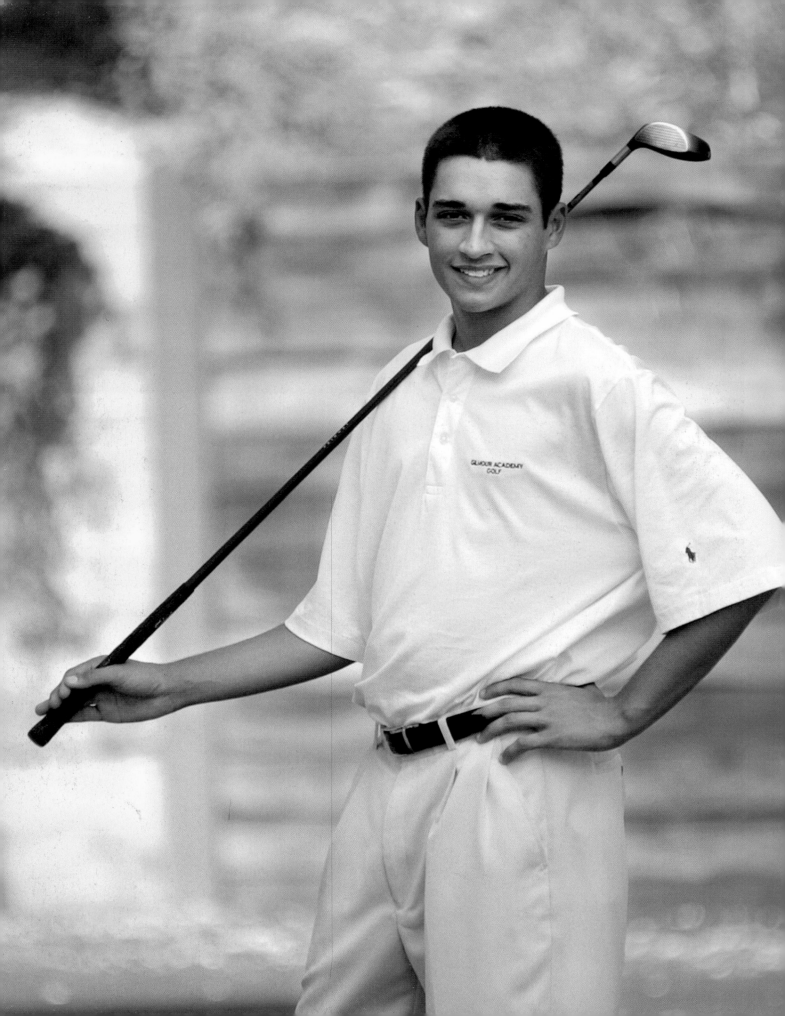

Camera Basics

Today, there are literally dozens of professional digital cameras for the photographer to choose from. Where do you begin in making a selection? The easiest way to make an informed decision is to identify the features that are most important to you and best suit the type of photography you do. It is important to remember that one single digital camera may not fulfill all of your photography needs. For example, if you routinely sell 20 x 24-, 30 x 40-, or 40 x 60-inch images to your clients, you will need a digital camera with a very large file size—preferably 12 megapixels or higher. A couple of the high-end 35mm digicams and all of the medium-format digital backs will fulfill this need nicely. However, those same cameras may not be the best choice for photographing a high school football or basketball game. For these

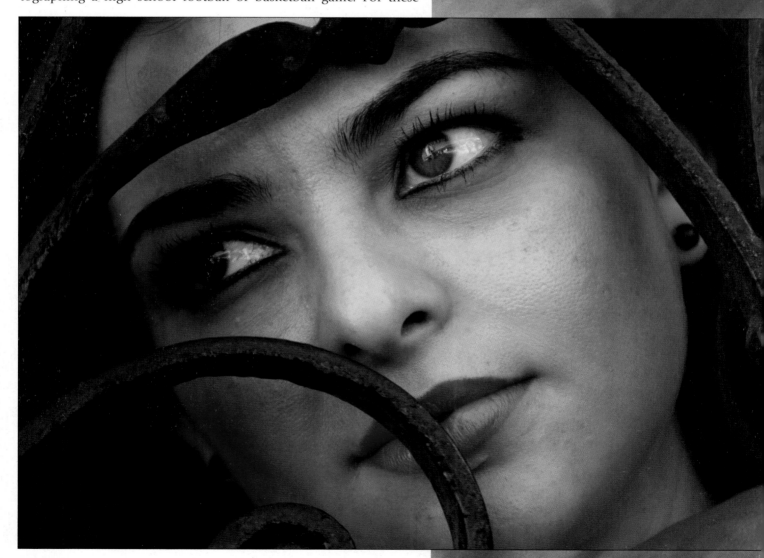

Facing Page—Image by Scott Gloger. **Above**—Image by Monte Zucker.

types of events, file size is less important, because the maximum print size you may be expected to provide is usually 8 x 10 inches or smaller. Speed is of far greater importance in these cases.

Many of the 35mm digicams offer variable ISOs from 100 to 3200. These fast ISOs will allow you to capture digital images in almost any lighting situation. Just like with film, the higher the selected ISO, the more grain or digital noise will be apparent in the image. Both Canon and Nikon have created 35mm digicams specifically designed for this purpose (the D30 and D1H, respectively). The cameras

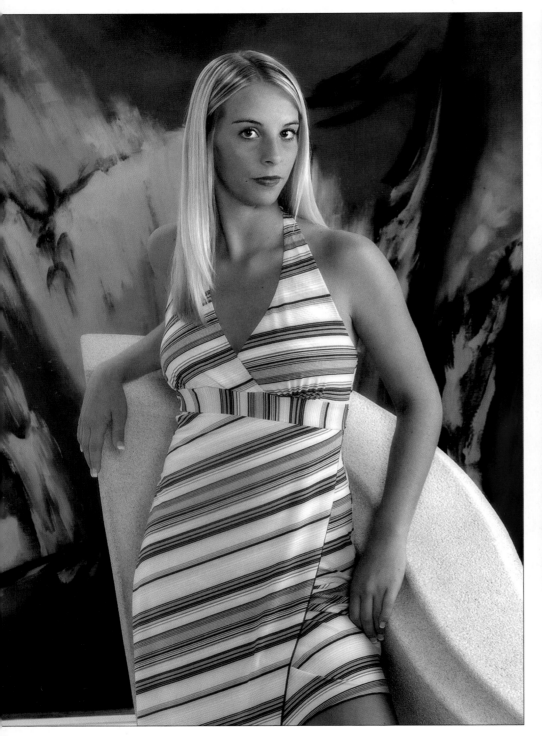

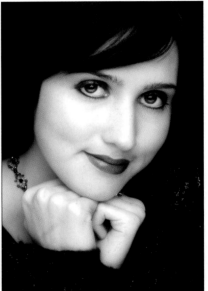

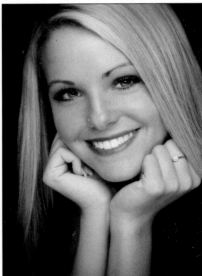

Digital cameras are more than capable of creating film-quality images and are more versatile than film cameras. Images by Leonard Hill.

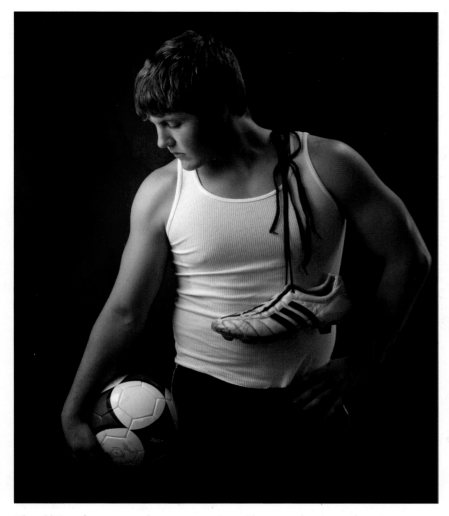

The addition of some personal props scores points with teens and seniors and can increase your studio's profits too. Image by Kathryn Sommers.

CCD. There are two popular types of sensors in most of today's digital cameras—CCD and CMOS. Most consumer digital cameras and some professional digital cameras use a Charge-Coupled Device (CCD) sensor.

The first sensors produced tiny images—only 320x240 pixels—but pixel density has steadily increased over the years, and we now see 6-megapixel and higher sensors from Nikon, Fuji (the new S3 has a 12-megapixel sensor), and Kodak (3000x2000 pixels) in some of their high-end digital cameras.

CCD sensors use an array of photodiodes, arranged in a grid pattern, to covert light into electronic signals. All CCD cameras use interpolation to create images. For example, a 3-megapixel digital camera only has 750,000 red, 750,000 blue, and 1.5 million green pixels, but the camera's on-board processor generates a 3-million-pixel RGB color image by interpolating the data from each neighboring pixel.

CMOS. Canon was the first professional digital camera manufacturer to use a Complementary Metal Oxide Semiconductor (CMOS) image sensor rather than a CCD. CMOS sensors have some advantages over CCD-type sensors. They use only a fraction ($^1/_5$ to $^1/_{10}$ as much) of the power that's used by CCDs, making them a great feature in battery-powered cameras. CMOS sensors are made using the same techniques and equipment as more familiar CMOS circuits like CPUs and RAM, so they cost less to produce than CCDs, which require specialized fabrication equipment.

Like CCDs, CMOS sensors use an array of photodiodes to convert light into electronic signals. The

have very high burst rates and can capture several frames per second for a few seconds before the camera needs to stop and render all of the images. These are ideal for sporting events and other action shots.

Over the last several years, most camera manufacturers have solved many of the problems that plagued earlier digital cameras. Shutter delay (the time between pressing the shutter button and the instant that the camera actually records the image) is no longer a problem with professional digital cameras. The older Nikon Coolpix 950 and 990 cameras that we use for infrared imaging have some shutter delay. We have learned through experience to take this problem into consideration when we are taking photographs.

weak electronic charge generated by the photodiode is stored in a small capacitor. The charge is too weak to be used by itself and must be amplified to a useful level.

The major difference between CCDs and CMOS sensors is in the way the stored charges are converted into a usable signal. A CCD sensor scans its pixels consecutively; stored charges from each row are actually shifted down to the next row and at the bottom of the array, and the charges in the final row are output in a serial stream. The voltage levels of each pixel in the serial stream are maximized by an on-chip amplifier prior to output and are sent to either an external or internal analog-to-digital converter (ADC) where the signals are converted into the array of bytes that makes up the image.

Each pixel in a CMOS sensor has its own amplifier circuit, so the signal amplification is performed

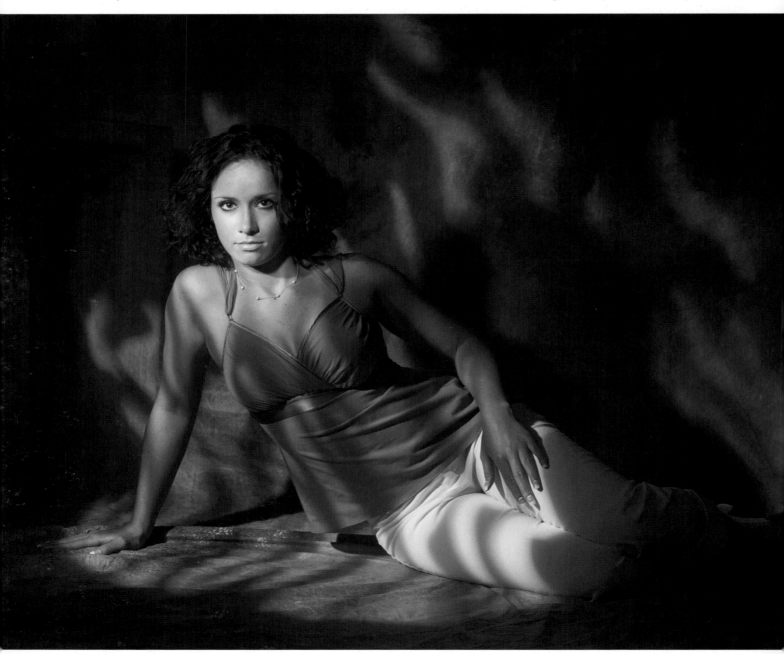

Image by James Williams.

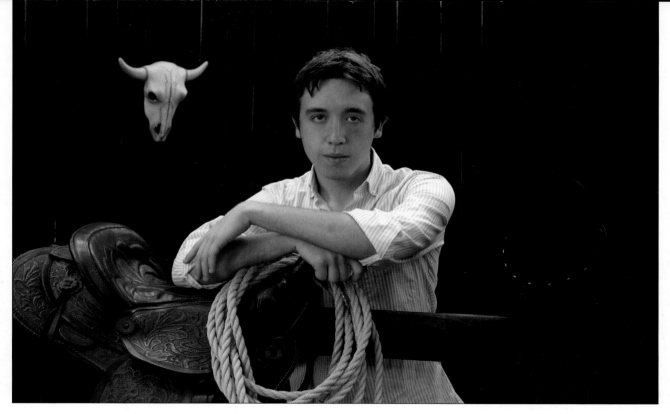

The more pixels your camera has, the more detail it can capture. Image by Patrick Rice.

prior to the image being scanned. The resulting signal is strong enough to be used without any further processing. Unlike CCDs, CMOS sensors often contain additional image processing circuitry (including ADCs and JPEG compression processors) directly on the chip, making it easier and faster to retrieve and process the picture information. This results in a lower chip count, increased reliability, reduced power consumption, and a more compact design.

Until the introduction of the first Canon CMOS professional camera, the Canon D30, CMOS sensors were generally regarded as a low-cost, low-quality alterative to CCD sensors and were typically found in inexpensive digital cameras. A major problem in older CMOS sensors was that some pixels often had more or less sensitivity than their neighboring pixels. This unevenness translated into noise. Canon solved the noise problem in the D30 by scanning the sensor twice—once before the shutter opens and again while the shutter is open. The "dark" image is electronically subtracted from the exposed image, thereby eliminating the noise.

So, what does this mean to the professional photographer trying to choose a chip platform? With the innovations of the past couple of years, it doesn't make that much difference whether your camera uses a CCD or CMOS sensor. Canon, Nikon, Fuji, and Kodak all produce great digital cameras that create outstanding files for the working professional photographer. While there are differences between the two technologies, I do not feel that the sensor is necessarily the deciding factor when choosing a camera. My recommendation to any photographer is quite simple: choose a digital camera that will allow you to use your existing lenses. If you already own 35mm camera lenses on the Canon platform, then choose one of the Canon digital cameras. If you own 35mm lenses on the Nikon platform, then choose the Nikon, Fuji, or Kodak digital camera bodies. This will save you thousands of dollars, and you will get great digital files regardless of which sensor your camera utilizes.

Our studio uses both Canon and Fuji 35mm digicams. The Canon D60 cameras have been steady workhorses for us. We have also begun to use a number of Canon 10D cameras. This is an excellent all-around digital tool that has produced consistently great results. The Fuji S2 is an incredible digital cam-

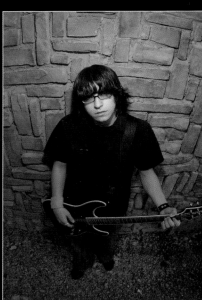

Be sure to take the necessary precaution to safeguard your photos. Images by Patrick Rice.

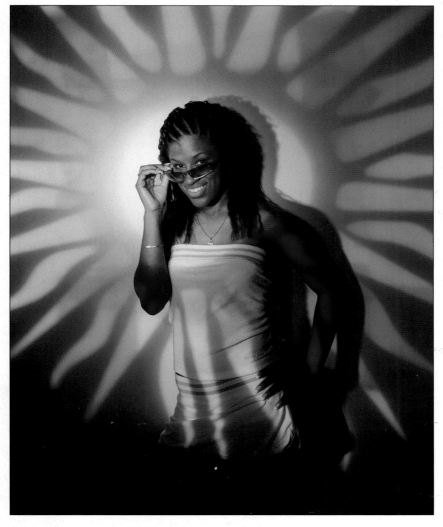

This background was created with the Tallyn F16 Turbo Spot attachment placed in front of a Photogenic Powerlight 600 monolight. Image by James Williams.

era with limitless potential. Coupled with the Tamron DI lenses, it is the finest camera made at its price point.

○ MEGAPIXELS AND RESOLUTION

A digital image is comprised of bits and bytes and, essentially, a long string of 1s and 0s represent all the tiny colored dots (pixels) that make up an image.

The amount of detail that the camera can capture is called resolution, and it is measured in pixels. Put another way, resolution refers to the maximum number of individual picture elements (pixels) the camera's sensor can capture. A megapixel (MP) is a million pixels, and the more pixels your image sensor has, the more detail the camera can capture. The more detail you have, the more you can enlarge a picture before it suffers from digital noise and starts to look out of focus.

A digital camera, just like a film camera, has a series of lenses that focus light to capture a scene. But instead of focusing this light onto a piece of film, it focuses it onto a semiconductor device (CCD or CMOS) that records light electronically. A computer then converts this electronic information into digital data.

Today's professional digital cameras range from 3 to 14 megapixels in 35mm-type cameras (the Kodak 14N and 14C have a 14-megapixel rating) and 48 megapixels and beyond for medium-format camera backs. The confusing part about the entire megapixel debate is how the camera interpolates the information it records. While having more megapixels available is generally better than having less, the best determination of camera quality is made by examining the maximum enlargement possible from an image. Any of the professional 35mm digital cameras (3 megapixels or higher) can make very acceptable enlargements up to 20 x 24 inches. Cameras in the 6-megapixel range can easily make 24 x 30-inch images and larger. The only time that the benefits of using a larger-megapixel camera is noticeable is on very large prints (beyond 20 x 24 inches) or when the subjects are very small in the photograph. The larger sensor provides more detail because the pixels are larger and can contain more information. This allows for larger magnification before any artifacts become apparent.

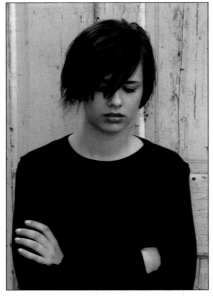

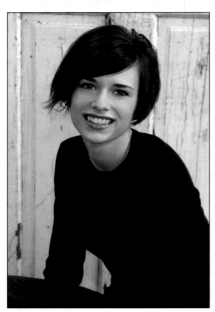

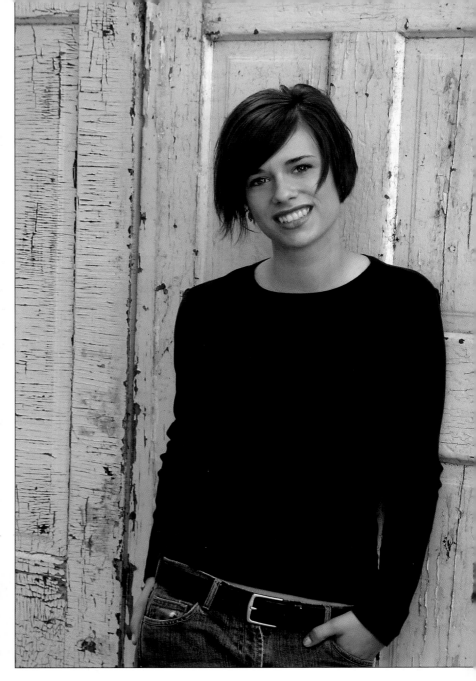

Seniors are highly discriminating. Keep your images fresh and stay on top of the trends that appeal to your clients. Images by Patrick Rice.

⭘ DIGITAL STORAGE MEDIA

With today's professional digital cameras, the photographer has a few choices with regard to storage media for their images. The most popular are microdrives, CompactFlash (CF) cards, and SmartMedia cards. Most cameras can accommodate microdrives and either CompactFlash or SmartMedia cards, but usually not both.

Microdrives came on the market very early in the evolution of digital imaging. Their advantages were their large storage capacity and fast read and write speeds in the camera and computer. They were also very inexpensive compared to the CompactFlash and SmartMedia cards. The major disadvantage of microdrives is that they are miniature computer hard drives that have moving parts enclosed in the housing. This presents two distinct problems. First, if a microdrive is dropped, it is possible that it may never work again, and the photographer could lose every image on the microdrive at the time. This has hap-

pened to a number of photographers that I have spoken with. The second problem is that a microdrive, being a computer hard drive, can crash. I haven't met a photographer who has not had their computer crash at one time or another and had to replace their hard drive and reinstall everything that was on the computer. Both of these scenarios present a considerable risk factor for the professional photographer.

We have chosen to use CompactFlash cards with our Canon and Nikon digital cameras. Compact-Flash cards are solid-state circuits with no moving parts to break. The cards are practically indestructible! I have met three photographers who have left CompactFlash cards in the pockets of their trousers and sent them through the washing machine and dryer without harming the card or the images recorded on it. CompactFlash cards were initially very expensive, had limited storage capacity, and very slow read and write speeds. This has all changed. The prices of CompactFlash cards have dropped dramatically—so much so that they are nearly as inexpensive as microdrives of the same storage size (1 gigabyte). Storage capacity for CompactFlash cards has actually surpassed that which is available for microdrives. Lexar Media has now introduced, 1-, 2-, and 4-gigabyte CompactFlash cards. These large-capacity cards can store hundreds of files and can be used with the latest 12- and 14-megapixel cameras. Last, the read and write speeds of professional Compact-Flash cards have also surpassed that of microdrives, with Lexar Media introducing 40-speed Compact-Flash cards.

Image recovery has become a major concern for today's digital photographer. Many companies now offer image recovery software to locate files on cards that are unreadable, images that have accidentally been deleted, and other worst-case scenarios. Lexar Media guarantees their professional cards for life and provides free card replacement and image recovery at their factory. Moreover, they have provided many camera stores with the same recovery software so the photographer can take their problem CompactFlash card to a retail outlet to recover images. Not only that, but now Lexar Media has included the image recovery software in the card itself and provides a free JumpShot USB cable. This extensive customer support has made us very loyal supporters of Lexar Media CompactFlash cards.

○ PRO TIPS: COMPACTFLASH CAUTIONS
One Card, Two Cameras, Three Headaches!
by Scott Tallyn

In working with the Data Recovery Team here at Tallyn's, one trend seems to be developing that needs to be addressed. Every camera has its own unique filing system. For example, a Fuji S1 camera and Fuji S2 have two entirely different filing systems, even though they are the same brand. Canon presents its own problem with the vast differences between their EOS 10D and EOS 1Ds cameras. When you take a card out of one camera and put it into another camera without formatting it, you drastically increase your risk of data loss. This is true even if the cameras are the same brand. It is kind of like taking a Windows 95 operating system and expecting a Windows XP disc to work in it. There is a good possibility that you can swap cards between two cameras and have no problem capturing images. The problem comes up when you put the card into a reader and try to download the images. The computer must guess which file format to go with and then toss the other one out, and all the images become truncated or unreadable.

Hopefully this advice helps prevent some mishaps in the digital world. In the event you have a data corruption issue, do take comfort in knowing the Data Recovery Department here at Tallyn's has a great history of saving many images and computer systems.

○ PRO TIPS: SAFEGUARDING IMAGE FILES
Six Simple Steps to Prevent Data Loss
by Scott Tallyn

As a professional photographer, I've built my reputation and livelihood on capturing quality images for my clientele. Like many other photographers, I was hesitant to make the switch from film to digital, but digital photography has revolutionized and revitalized my outlook and increased my creativity. I will

never go back to film. But while digital photography is a very powerful tool, I have experienced a few glitches that all digital photographers should be aware of.

My first experience happened when I opened a media card through my reader only to find that there was nothing on it. My heart sank down into my shoes, sheer panic set in . . . my images were gone! These pictures were not something I could reshoot, and they were nowhere to be found. This was the start of my research into data recovery.

What is Data Recovery? Data recovery is a process that retrieves lost or reformatted data from electric storage media. Even after data has been deleted, reformatted, or corrupted, in most cases the original file exists on the storage media (but isn't visible to the user). Data recovery locates and extracts the lost information.

Through my experiences in data recovery, I've been able to narrow down what causes a majority of data loss or corruption, and how these problems may be avoided.

Six Simple Steps to Prevent Data Loss. Here are the six most common human errors that may cause data loss and corruption:

1. *Sharing the same media card between two different cameras.* Never write data to a particular card then interchange it between cameras of different makes or models. Each camera writes information to the card in a different way, so using the card in different cameras will alter the file allocation table, thus making the information inaccessible. If you wish to use a card in a different camera, be certain you have your data saved to your computer or an alternate storage device, and then reformat the card in the camera you wish to use.

2. *Turning off the camera before it is done writing information to the card.* When you turn the camera off before it is done writing information to the card, part of that picture will be corrupted. This may also corrupt part or all of the other files on the card. Never turn the power off while data is being written to the card.

3. *Neglecting to change batteries when they get low.* When your batteries begin to get low, stop immediately, turn off the camera, and replace them. When the camera does not have enough power to write to the card, it may corrupt the current file—and damage every other file on the card too.

4. *Pushing the preview button before the camera has finished writing information to the card.* If you hit the preview button frequently, please beware not to do so while data is being written to the card. This may corrupt your data. I have encountered this numerous times and have even been guilty of doing this myself.

5. *Opening the access door or trying to eject the media.* Never open the access door to your media card or attempt to eject the card while data is being written to it.

6. *Breaking communication between the computer and the media card (PC users).* This is a frequent mistake that many photographers are not aware of. As a safety precaution, I highly recommend that you double click on My Computer, find the letter drive associated with your card/reader (e.g., E Drive), right click on that drive, then select Eject from the menu (in all operating systems). This line of defense does not physically eject the card from the reader, but it breaks communication between the computer and card. If you simply physically eject the card from the reader and put in a new card, the computer believes it is still talking to the first card and may corrupt data on the second card.

Recovering Lost Data. Follow these simple steps to recover your lost data.

1. *Do not continue using the device.* This is the most important step! If you continue to use your storage device after you've discovered missing information, there's a good chance you will write over the lost data. Once the data has been written over, it is completely gone, and there is no chance of a full recovery.

Images by Michael Ayers.

2. *Use a data recovery software program.* You can find many low-cost data-recovery software programs online. However, a word to the wise: you get what you pay for! Many of these programs may not recover all of your data, and some may cause more harm than good. I have unsuccessfully attempted to make many data recoveries that were beyond my help due to amateur attempts with poorly designed software. If your data is extremely important or irreplaceable, contact a data recovery firm that specializes in this area.

3. *Consult a professional recovery service.* If your data is highly important, seek the help of a company that offers data recovery services, but be forewarned that many are extremely expensive. To offer a more affordable solution for amateur and professional photographers, I formed a new division of my business (Data Recovery Services). For more information about Tallyn's Professional Data Recovery Services, visit www.tallyns.com/DataRecovery.htm or call us at 800-433-8685 (United States only) or 309-692-5005 (overseas/United States) and ask for Scott Tallyn or Carissa Trew.

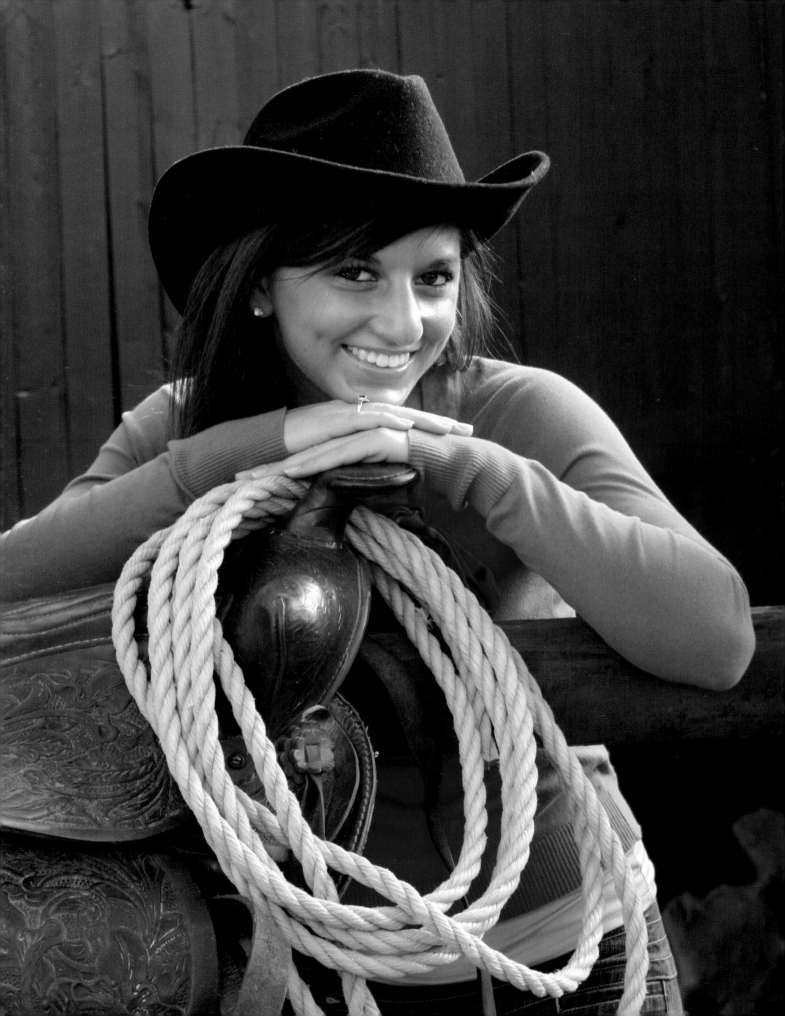

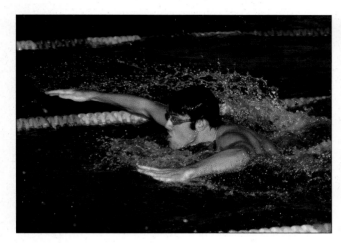

*Facing Page—Image by Barbara Rice. **Above**—The lens magnification inherent in shooting with your "film" lenses on your digital camera is a great asset when it comes to freezing action. Image by Robert Williams.*

⦿ LENSES FOR DIGITAL PHOTOGRAPHY

For portraiture, most photographers use telephoto lenses. In the days of medium-format cameras and lenses, a photographer would generally use a 150mm or 180mm lens for portrait work. These telephoto lenses provided a compression of the subject and background that is very flattering to the subject. Telephoto lenses also have a shallower depth of field, which keeps the backgrounds less in focus and thus less distracting.

With 35mm film cameras and lenses, the recommended focal length for portraiture is 135mm. The difference between 35mm and medium format is on account of the size of the film that the image is being recorded onto.

With digital cameras, the correct lens for portraiture depends on the magnification of the digital camera. The Canon 10D has a 1.6 magnification factor, which gives the lens an effective focal length that is 60 percent greater than the focal length listed by the manufacturer. In other words, when used with the Canon 10D camera, a Canon 100mm lens would be effectively a 160mm. The Canon 100mm lens and the Tamron 90mm lens both make excellent portrait lenses with the Canon 10D. Many photographers now use zoom lenses in the studio with their digital cameras. Zoom lenses provide the photographer

with a wide range of focal lengths and allow them to go from a close-up to a full-length image very quickly, without changing the lens. The rules to determine the effective focal length apply the same to zoom lenses.

⦿ FLASH

While we'll get into a deeper discussion on flash shortly, for now it is important to note that you have two options when shopping for a flash unit. You can choose a dedicated flash—say, a Canon flash for your Canon camera—or one made by a company like Metz, Lumedyne, and others. We'll get into the pros and cons of using dedicated flash vs. non-dedicated flash in the next chapter.

Exposure and Lighting

Lighting considerations for digital photography are not much different than they are for film photography with one big exception—with digital, the photographer has more control.

○ WHITE BALANCE

White balance is based on the color temperature of the light that is present in a scene. The three primary colors—red, green, and blue (RGB)—exist in all lighting situations in varying degrees. When the color temperature of a scene is low, then there is more red; but when the color temperature is high, there is more blue.

The human eye is very adaptive and quickly compensates for different lighting conditions so that colors appear natural regardless of the lighting situation (color temperature). Cameras are not so adaptive; they simply record the color temperature that exists. With film cameras, a photographer had to choose film that matched the color temperature of the light that the photo would be taken under or he would get a color cast. The photographer would place a color correction filter in front of the camera lens to adjust the film to the light. With digital cameras, this is no longer necessary.

Presets. All professional digital cameras offer white balance (WB) settings that allow the photographer to record the best color rendition in any given lighting situation. Most cameras have an auto white balance (AWB) setting that can be used as the default setting for any lighting situation. In the auto white balance mode, the camera's sensor automatically chooses the best white balance setting for the lighting that it detects. This is a huge time saver for the photographer who has to work quickly and doesn't have time to change film types or place filters in front of each lens.

Digital cameras have several white balance options to match any lighting situation. Besides the auto white balance setting, the photographer can set the camera more specifically by choosing one of the preset white balance settings—usually depicted in symbols. The symbol of the sun is for bright, sunny days. The symbol showing clouds is for cloudy, hazy, or overcast days. The symbol depicting a lightbulb is for tungsten light. The symbol depicting a fluorescent bulb is for fluorescent light. The symbol showing a lightning bolt is for flash photography. Some cameras show a symbol that depicts shade for subjects placed in shaded areas of the scene.

Facing Page—A personal prop makes for a dynamic image. Image by James Williams.

Unique lighting may require that you use the custom white balance setting on your camera to ensure the ensure correct color rendition in your image. Image by Barbara Rice.

○ CUSTOMIZING THE WHITE BALANCE

Most digital cameras have a custom white balance setting that allows photographers to shoot a white card or another neutral device and use that data as the standard for the white setting in that scene. More advanced digital camera models have a Kelvin (color temperature degree) setting that allows the photographer to manually select the exact color temperature for a particular scene using a color temperature meter.

While the auto white balance produces good results when used in scenes of average color and lighting, mixed lighting, scenes lacking a neutral white or gray tone, and those predominantly made up of a single color can spell trouble. This is where the custom white balance setting comes in.

The ExpoDisc vs. Gray Cards. We use Wallace ExpoDisc's digital white balance filter to set an accurate custom white balance in tricky lighting conditions and ensure color fidelity in our images. To use it, attach or hold the filter on the front of your lens, take a reading, and set the color balance.

In pure daylight conditions, the ExpoDisc has a value of Red 128, Green 128, and Blue 128 and looks like a neutral gray card. By setting this as your custom white balance, you provide the camera with a point of reference for determining neutral gray. Equipped with this information, the camera can determine how much the RGB values in the image deviate from Red 128, Green 128, and Blue 128, and can add the opposite colors in the right amount to achieve a neutral gray. Because the ExpoDisc collects light from 180 degrees, it effectively collects and averages light from all the light sources in the scene. This makes it a better and more accurate tool than a gray card, which can be influenced by fading, glare, lens flare, or reflections.

In addition to being more accurate than using a white or a gray card, the ExpoDisc is more portable and can easily fit in a camera bag, pocket, or purse. Another plus is that taking a reading is fast and easy—and produces accurate results. It seems a much better option than spending exponentially more time in the digital darkroom making hit-or-miss attempts at color fidelity.

○ FLASH PHOTOGRAPHY

In many photographic situations, there will not be enough ambient light to record the image in the desired way. In these situations, the photographer will need a portable flash unit or studio lights to properly illuminate their subject. Both Canon and

Nikon have introduced specific flash units designed to be used with their digital cameras. These dedicated portable strobes optimize all of the camera's features and allow for total integration of features and performance. For example, when used with Canon digital cameras, Canon's 555 EX flashes can sync from 30 seconds up to $\frac{1}{4000}$ of a second. This is ideal for fill flash situations outdoors when you need a little light in the subject's eyes but do not want to overpower the existing light with the strobe. If you use a non-Canon flash, the flash synchronization is from 30 seconds to only $\frac{1}{250}$ of a second.

Another benefit is that through-the-lens (TTL) metering capabilities exist with these dedicated flash units so that the photographer can allow the computer in the camera to determine how much light is necessary for proper exposures in just about any situation.

Photographers can still use other flash equipment with their digital cameras. Most every digital camera has a PC connection and a hot shoe on the camera body. Your flash can be plugged into your digital camera in the same way that you plugged it into your old film cameras. Some digital cameras are more sensitive to the high voltages that can emanate from some flash units. These high voltages can burn up the digital camera's circuitry and destroy the camera—and the damage won't be covered under your warranty.

An easy way to prevent this problem is to use a safe sync on your camera's hot shoe. This inexpensive voltage regulator (about $60) converts the voltage from any flash unit to a constant 6 volts—a voltage that will not have a harmful effect on the camera. You can think of the hot shoe safe sync as a surge protector for your camera.

We see the safe sync as cheap insurance and use them on every digital camera. We also use them with

Dedicated flash units offer through-the-lens metering capabilities. Left image by Kathryn Sommers. Right image by Patrick Rice.

our Profoto studio lights, and have for many years. We simply plug these lights into the safe sync and shoot like we did with our film cameras.

○ STUDIO LIGHTING

Lighting in the studio is handled the same way for digital that it was for film cameras. We use 300- and 600-watt-second Profoto ComPact units for our studio work. They have a diameter of only 10 centimeters and are some of the photo industry's most compact all-in-one models.

It is very important that the color temperature of your light output remains constant throughout the day. With some lighting systems, the color temperature output can vary as the bulbs heat up, negatively impacting the color balance in the scene. Corrections can be made in one of two ways: by constantly setting a new custom white balance in the studio or utilizing Photoshop post-capture to neutralize the color casts. Both options are very time consuming. Fortunately, the Profoto units are equipped with a silent fan that works to keep the bulbs cool for problem-free, continuous use.

Profoto also offers a complete line of light modifiers and reflectors for any photographic situation. These light-shaping tools have the ability to create a different and distinct character of light. Profoto uses the same reflector mounting bracket on all lamp heads, allowing the photographer to interchange the modifiers at a whim.

Expertly controlled lighting is a hallmark of great portraiture. Image by Leonard Hill.

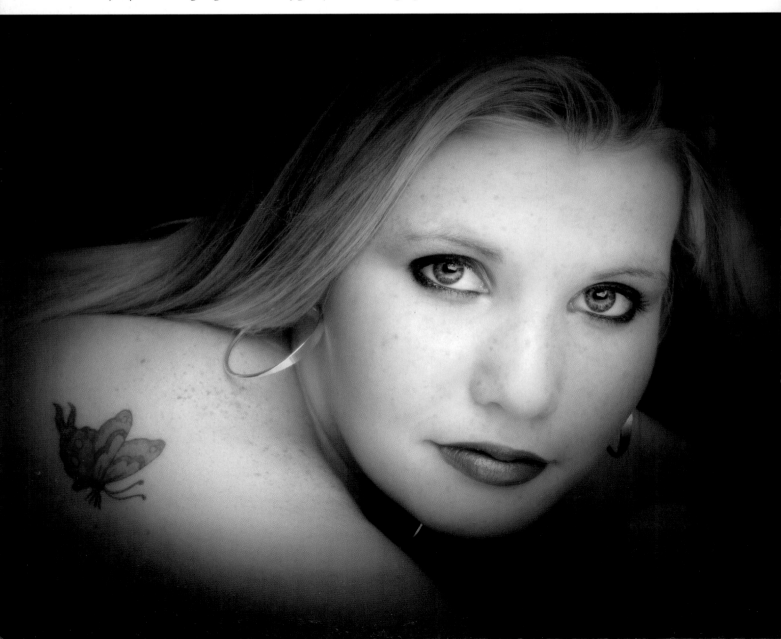

Efficiency in the Camera Room

How efficiently a photographer sets up their camera room will greatly influence how they will create portraits. It is essential to make your camera room as photographer-friendly as you can. Unfortunately, each studio photographer has only a limited amount of time that he or she can spend with each student. Because of this, everything about the studio's camera room must work to make our lives easier. Let's face it; if anything becomes a lot of extra work, we are unlikely to do it.

O BACKGROUND SYSTEMS

All told, there are nearly twenty backgrounds in our studio that are suspended and can be accessed for any session. We occasionally visit fabric stores to purchase interesting and colorful material to use in photographs. Compared to commercially available photographic backgrounds, these are a real bargain and can add variety and uniqueness to any portrait. To easily access these, we utilize the Ontrax system, which allows us to move the desired background into place and move others out of the way in just seconds. The track contours to the bends in the walls, and its strap system keeps the muslins off the floor. The muslin clips that hold the background to the rail don't even put holes in the backgrounds like grommets do. We can even remove the background completely for use off-site if necessary! It is an ideal system for any studio, and it comes with a lifetime guarantee.

We also utilize Bogen's chain-driven background systems. This simple chain mechanism raises or lowers any mounted background with ease. This is ideal for any of our canvas or roll-paper backgrounds, which cannot be used with the Ontrax system. We mounted a piece of wood to the bottom of one of the canvas backgrounds on the chain-drive system so that when this background is rolled up, we can clamp other backgrounds to the wood as necessary. This is especially convenient when we want to hang smaller fabric backdrops for a portrait.

We've also purchased two electric motor-driven backgrounds that we enjoy for their speed and convenience.

O CAMERA STAND

We use a very old Majestic camera stand in the studio for most of our portraits. This stand is durable and easily adjusts from as low as 18 inches to as high as 7 feet. The stand has a Custom Brackets–brand rotating camera bracket permanently affixed to it. This bracket allows us to easily rotate the camera from vertical to horizontal.

○ LENS SHADES

Attached to many of our camera lenses are Lindahl lens shade systems. We use many of their shades, including the Professional Vignetter and Bell-O-Shade models. These items have been standard equipment in many studios for decades, yet photographers do not seem to utilize them as much with their digital cameras. I feel this is short-sighted. The dwindling use of these accessories seems to stem from the possibilities afforded in Photoshop and other image-editing programs. Unfortunately, photographers have forgotten an all-important axiom that we were all taught in this profession: get the image correct in the camera! Doing just that will save you time and give your images a more professional touch.

I have found that with digital capture, I use a little less diffusion than I did with film. We have always used the Tallyn drop-in filters with the Lindahl shades. The #1 and #2 soft-focus filters are usually

Top image by Kathryn Sommers. Above image by Lisa Smith.

Eliminating a color cast can be time consuming using image-editing software. Using the Wallace ExpoDisc (see page 30) greatly reduces or completely eliminates the need for post-capture image corrections. Image by Barbara Rice.

best in most situations—especially with high-school senior photography. While diffusion can be done in Photoshop, I prefer to create it in the camera. In addition to saving me time, this strategy allows me to show the effect to the client when I'm conducting a proofing session immediately after the shoot. In these cases, you don't have the luxury of being able to enhance the image later.

Too many photographers are showing clients mediocre images and telling them, "we can fix it later." Although this statement is true in most cases, making such a claim does little to instill confidence in your abilities as a professional photographer.

Creating the desired effect during the session will save considerable time, and in our business, we need to reclaim all of the time we can.

⊙ ELIMINATING COLOR CASTS

Though your camera's auto white balance setting may produce acceptable results, there are some situations that can fool the meter into misreading the scene, and a color cast can result. Fixing this problem in Photoshop could be very time consuming. We've found that using the Wallace ExpoDisc (as discussed on page 30) greatly reduces or completely eliminates the need for post-capture image corrections.

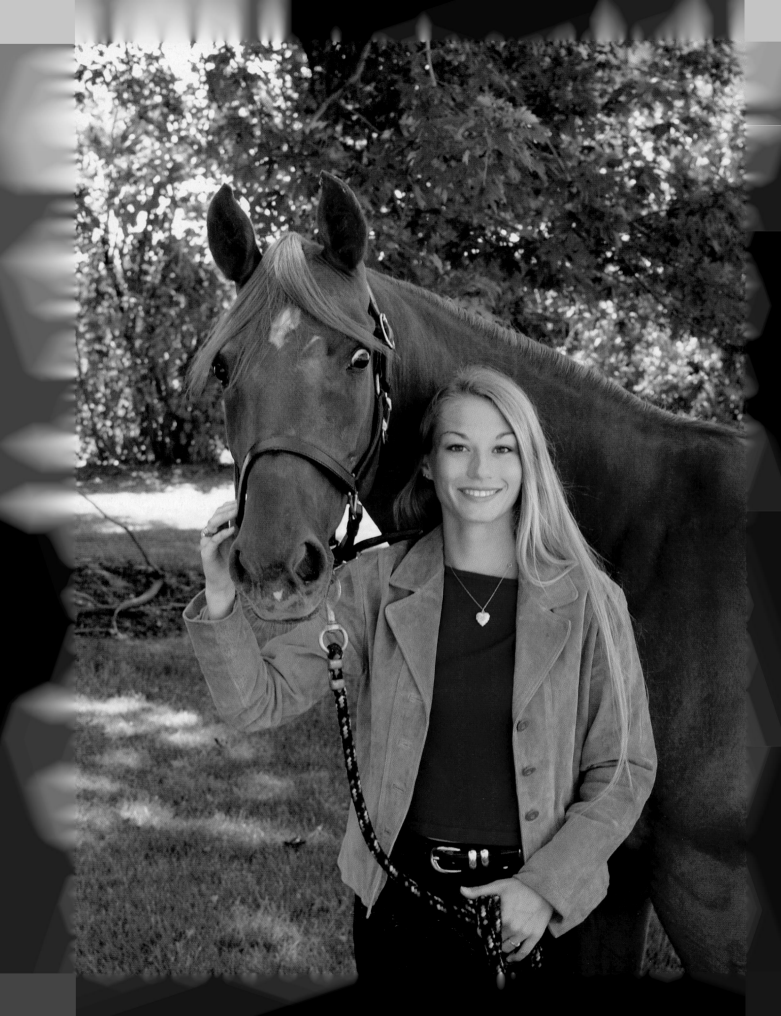

Post-Capture Essentials

With digital, photographers have more post-capture responsibilities than ever before—and with these responsibilities comes increased control.

O MONITOR CALIBRATION

With digital photography, monitor calibration is essential. With a properly calibrated monitor, you can ensure that the colors you see on your computer screen will match the color output by your printer. In our studio, we use the ColorVision Spyder monitor calibration system. This device is fast and easy to use and is relatively inexpensive (under $400). All of our monitors in the studio are calibrated the same way to ensure consistent results regardless of which machine the color adjustments were performed on.

The award-winning Spyder is an all-digital, seven-filter colorimeter that works with both CRT and LCD monitors. Working together with the wizard-based PhotoCAL software, which guides you through the calibration process, the Spyder calibrates your monitor to a universal standard for color and automatically creates a correct monitor profile. The end result is a monitor that displays accurate color and lets you trust what you see on your screen. Select your gamma and color temperature and then attach the Spyder to your screen. PhotoCAL does the rest! An advanced feature to balance the RGB guns of your monitor is also available to further optimize your monitor's performance.

Your monitors should all have hoods around them to block any stray light from striking the monitor screen and influencing the photo technician's color evaluations and adjustments. In our studio, we block outside light sources and use daylight-balanced bulbs to prevent any color temperature variation. Some photographers have even gone so far as to have their staff wear a gray apron when working on files so that the employee's clothing colors are not reflected back onto the screen.

All of these points are suggestions for any studio that seeks to produce consistent results and wants to eliminate costly remakes and save time. With digital photography, we now have the ability to control and adjust every part of the photographic processes—from image capture to output.

Facing Page—A carefully calibrated monitor is essential for a high-quality digital portrait. Image by Michael Ayers.

A properly calibrated monitor will allow you to visualize the color of your final prints and will help you ensure that each of the images from the single session have good, consistent color. Images by Chad Tsoufiou.

⊙ DIGITAL WORKFLOW

Digital workflow for the photographer does not have to be as complicated and time consuming as some photographers purport it to be. Many digital photographers have established very simple workflow procedures that keep them from being bogged down by overwhelming and unnecessary image storage methods.

Our studio employs very simple digital workflow procedures. Our images are all written onto CompactFlash cards by the camera at the time of image capture. We do not spend time downloading the images from the CompactFlash cards during the session or try to write CDs when we should be creating images.

File Storage. All of the image files from each CompactFlash card used are written to a CD as RAW (or uncorrected) camera files. No manipulation or editing is performed.

The CD is labeled with the client's name, the date of the session, and the photographer's name. We use a special marking pen designed specifically for writing on CDs that eliminates the possibility of the ink bleeding into the data and corrupting any of the files.

Some studios prefer to write their images to DVD. The price of DVD writers for computers has dropped dramatically, and recordable DVD prices have become more reasonable, making this option especially useful for studios that shoot several hundred or even thousands of images at each session. Because of

their considerably larger storage capacity, saving your image files to DVD also means a tidier, more compact storage system.

Once stored on CD or DVD, these files become the "negatives" for all of the client's images.

Proofs. If we are showing the client the images immediately after the session, we load the Compact-Flash card into the computer's card reader and open up all of the images in the Fuji StudioMaster Pro software. This program allows us to quickly rotate every image and then show the client a slide show of their entire session. We can even use this versatile software to compare images on the screen and help the students select their images.

We only proof sessions if the client is willing to pay a $250 deposit to take the photos out of the studio. Many of our clients choose to simply make their selections right in our studio on our monitor. This saves us considerable time and money and helps to expedite the ordering process.

If we are making proofs for the client, we burn our uncorrected files (captured in the High JPEG setting) to a CD. This CD is never altered and never leaves the studio. We open these images and make any necessary corrections and enhancements, burn a CD of the corrected files, and send this new CD to the color lab for proofing. (This is important because we no longer have to be concerned about something happening to our images. With film, the rolls could be lost or damaged in transit to the lab. Furthermore, once the film safely arrived at the lab, it could be lost or damaged there as well. We have all had experiences where a roll of film came up missing or an equipment problem damaged some of the film!)

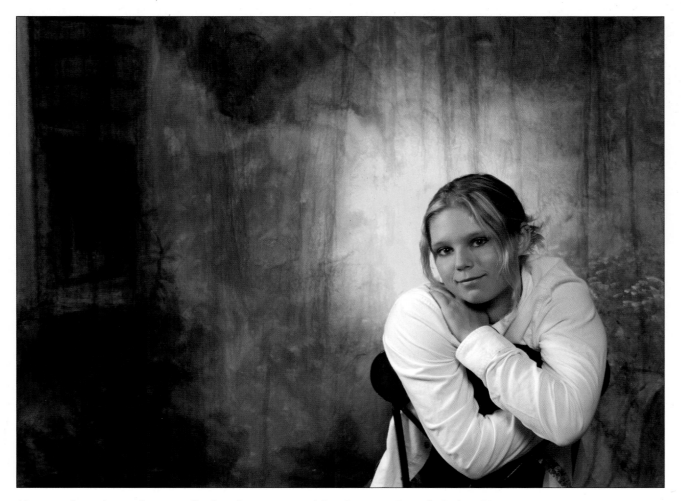

No matter the means you choose, proofing is an important part of the sales process. Image by Barbara Rice.

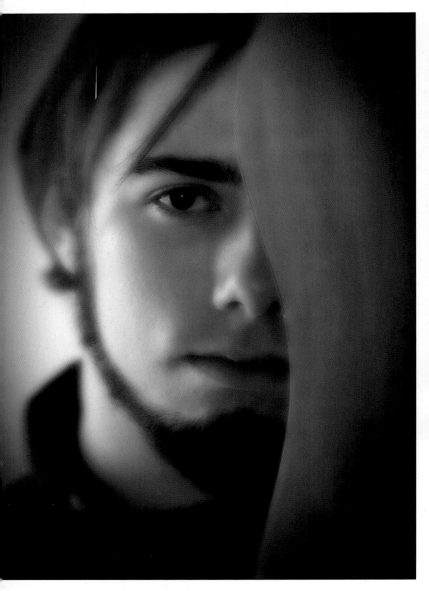

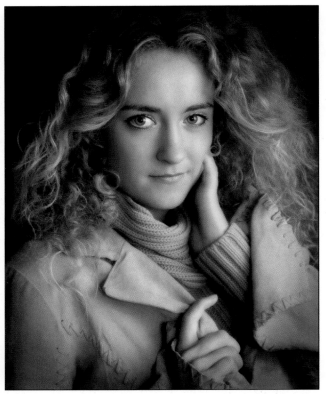

The digital workflow need not be intimidating. When you capture incredible images in the camera, the post-capture process is a relatively simple one. Images by Leonard Hill.

People see the intensity and saturation of certain colors differently. Men tend to suffer from some color blindness that gets worse as we age. I recommend that anyone working with digital files be tested by an ophthalmologist to determine if they have a deficiency in any particular color. A number of photographers I've met have had their eyeglasses tinted in such a way to correct their color vision. These tinted lenses are very subtle and do not have a strong color tint to them. They are meant to enhance the colors that the individual does not see well without affecting their ability to see other colors.

When the proofs are returned from the lab, the proofing CD is retained in the client file with the uncorrected-file CD, which serves as a backup.

Orders. When orders are placed and any changes and corrections are made to the image files, another CD is written. This third CD is then sent to the lab, and the necessary enlargements are printed. Once the prints and CD are returned, the CD is placed in the client file. We then have a permanent history of each image presented to the client and what they looked like. This system is far superior to film because, with film, the same negatives are used repeatedly throughout the process.

In the past couple of years, many color labs, including one of our favorite labs, H&H Color, have set up File Transfer Protocol (FTP) sites where a studio can upload their digital files directly to the lab. This saves on both the time and expense of burning a CD and shipping it to the lab.

Digital Output

Digital output is probably the biggest area of concern for today's buyers of photography. As digital imaging evolved, two unique problems occurred with regard to digital output. First, many early digital cameras had too small a file size to make adequate quality enlargements. Both consumers and photographers were trying to enlarge digital images beyond the point of acceptability. This is somewhat similar to excessive film grain with 35mm enlargements, except that pixelization from over-enlarging digital images is far less attractive. The second early problem with digital output was the quality of the printers that were available to both professionals and consumers. The inks used in early inkjet printers were not very true to the color in the scene, and the papers that the prints were printed upon did not last. In other words, the images tended to fade or shift colors over time. Digital output turned many people off about digital imaging.

⭘ LAB OR IN-HOUSE PRINTING?

Today, it is not necessary for the professional photographer to print any of his digital images. Just about every professional color lab on the globe can now accept digital files and make prints on Kodak or Fuji photographic paper. Moreover, in many cases, these labs use the same machines to print from film and digital files. This is a very important selling point when we discuss digital imaging with the clients. Some clients have the misunderstanding that their digital prints will not last. This is due in part to experiences with early inkjet prints and from misinformation from publications and photographers. Once our clients know that the same Fuji Frontier Printer will generate proofs and enlargements from a CD or a negative and print them on the same Fuji Crystal Archive paper, they are much more comfortable with the fact that we are a digital studio.

Our studio, like many others, has purchased in-house printers for use in specific applications. We were very happy with our results from the Epson 2000P and have since upgraded to the newer Epson 2200 printer. We use this printer when our client needs immediate turnaround on their images and to make watercolor prints for our clients. When you calculate the cost of ink cartridges, paper, waste, and time, these prints that we make in-house cost more than having prints made at the lab. In addition, the professional color labs are more consistent in color and density than most prints that photographers make in-house. I have known several photographers who have attempted to print some 8 x 10-inch portraits using their

inkjet printer, only to have the client reject them for lack of quality when compared to a lab print. Like with any photographic print, the real test is when they are compared to another print from the same event that was printed on a different machine or paper. The new generation of inkjet printers are very good and can produce quality images. However, for consistency, the photographer must maintain proper calibration of their monitor and profiles of their printers. (A profile is a description of the characteristics of a device that is used by other devices to manage or alter their own behavior. Profiles can be tagged or imbedded in a data file so that when the data file is opened, devices compliant with that particular profile can read the imbedded information and utilize it to interpret the data.)

Although some photographers print their own 4 x 5- or 4 x 6-inch proofs, this is not cost effective. Many of the larger discount and department stores can produce proofs from a Fuji Frontier printer on Fuji Crystal Archive paper at a cost of between 20 and 40 cents with turnaround times from an hour to next day. Professional color labs have also become more competitively priced in the area of digital proofing. Your color lab can produce your proofs for far less money than you can yourself.

Dye-sublimation (dye-sub) printers produce very fine quality digital images that are superior to those made by most inkjet printers. We have used a small Canon CD 300 dye-sub printer for many years to produce high-quality digital quick prints.

When processed at a lab, digital prints are made using the same printers and papers that were used with film. Image on left by Dennis Valentine. Above image by Ken Holida.

In the high-school senior photography business, many studios have contracts with their local schools that may allow them the exclusive right to create yearbook photos. Below, we'll look at the differing marketing strategies that contract and noncontract studios should rely on to ensure a lucrative business.

O OBTAINING A SCHOOL CONTRACT

Having a contract with a specific high school in your market area can be a lucrative arrangement for any photography studio. School contracts are different from state to state and school to school. If you are looking to enter into a contract with a particular school, consider the following key issues:

1. If binding contracts are permissible in your state, will the contract be binding (closed) or open? Binding contracts require each senior to go to the contract photographer for their yearbook photo. Photographers with binding contracts also have the right to photograph all sports (both team photos and action shots), dance, and prom photography. Open contracts allow a senior to go to another studio for their yearbook photo, so long as the image they submit from the other studio meets certain guidelines (usually a head-and-shoulders photograph on a particular color background).

2. With most school contracts, the studio must photograph each sports team, cheerleading squad, band, etc., at no charge and provide these images to the school. The studio can sell images or packages to the students involved in these activities.

3. With most school contracts, the studio must photograph all of the school staff at no charge and provide these images to the school.

4. In most cases, the studio must deliver all of the images they are providing to the school.

5. With some school contracts, a commission or percentage of sales must be rebated to the school.

6. As per some school contracts, the studio may need to provide cameras and film to the school at no charge.

7. With most school contracts, the studio will have to provide "game action" photographs to the school at no charge.

8. Will the winter formal and prom photography be part of the contract? School dances are very lucrative to photography studios, with over 75 percent of all couples purchasing prepaid photo packages at the dance itself.

Contract and Noncontract School Photography

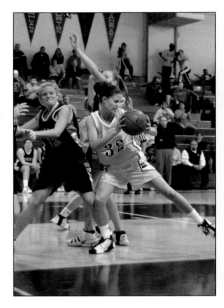

Left—The contract school's yearbook staff might be especially interested in an action shot like this one. Image by Robert Williams. Right—As a contracted photographer, you may be required to shoot team photos. Image by Robert Williams.

Depending on the size of the school, a studio may need to hire additional photographers or use members of their staff to provide some of the services mentioned above. It would be nearly impossible for a one-man operation to handle all of the needs of a school contract in a moderately sized to large school.

School contracts are very competitive. Contact your local school(s) and ask when the current contract expires. Find out if you can bid on the next contract. Also, ask for a copy of the current contract so that you can understand what the contract photographer currently provides. With high-school senior contracts, service is everything! The studio needs to be very proactive in meeting the needs of the school. Remember that many schools need images from the studio almost immediately or require very tight deadlines. The studio must be accommodating to maintain their contract. As one local contract photographer told me, "When the school sneezes, I'm there to wipe their nose."

O CONTRACT STUDIOS

In my market area, most high school seniors must go to the school's contract photographer in order to be included in the school yearbook. Unfortunately, in Ohio, binding contracts are not illegal like they are in most states. (In other Ohio market areas and in other states, binding contracts are less pervasive.) Many of the large contract studios insist on binding contracts when they secure the contract for a school. For independent studios like ours, this means that our seniors must go to these large contract photographers for their "yearbook only" session.

Even when students realize that they can have their yearbook portrait taken by the contract photographer and can hire another photographer to make other, more personal portraits, for some, it seems too much trouble. Many students will not want to go to two different photographers for their senior portraits. Many male students have very little interest in getting their senior pictures taken. Their parents may in fact have to force them to get their portraits made. These students will probably want to do this only once (if at all). This can also be a problem for female students. Yes, females care more about their pictures than the guys do. However, they go to a lot of trouble to make their pictures perfect. Many have their hair, makeup, and nails done the day prior to the session. Some borrow clothes to be photographed in. These clients may not want to go through all of those preparations twice. The contract photographer will win the students' business in these situations.

Rice Photography

31109 Lorain Road
North Olmsted, 44070
(440) 979 0770
www.ricephoto.com

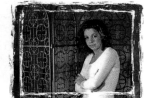

It's Not A Great Deal
If You Don't Get Great Pictures!

Dear High School Senior,

By now, you have probably received several mailings from different photography studios all wanting you to choose them as you high school senior photographer. You have probably seen the discount session fees and free wallet specials that everyone offers. All of those things are good, but keep one important fact in mind – *It's not a great deal if you don't get great pictures!*

Like everything we purchase, bargains are only a bargain if the product that you receive is actually worth purchasing. Cheap items are still just cheap. At **Rice Photography**, creating the highest quality, most creative senior photography is our number one priority. Patrick and Barbara Rice have trained with the finest photographic instructors from around the globe to provide a level of craftsmanship that is second to none. Their photography has earned almost every award possible in the field of professional photography. They have even published photography books! Ask any of the other studios if they can match these accomplishments. The point is simple – at **Rice Photography** we are confident that you will love your portraits. We want you to have fun and express yourself in each image. Bring along your friends, your pets, your car, anything at all that will make your photos more personal and not just like everyone else's. We have even installed satellite radio so that you can listen to your favorite type of music during your extensive portrait session.

You have many choices when it involves selecting a studio to photograph your senior pictures. Don't just consider the specials or the bottom-line price when making that choice. Remember, these are the most important photos that you have ever had taken of you. Make the right choice for you. Call **Rice Photography** at **(440) 979 0770**. It's one choice you won't regret!

Today's students are savvy customers. Make sure that your marketing materials give you a competitive edge. Promotional materials by Rice Photography.

○ NONCONTRACT STUDIOS

As a noncontract photography studio, we do not have the same access to these students and must find ways to convince students to get their portraits taken at our studio.

One of the first mailings we send to students deals with the contract photographer issue. The letter, which is a modified version of one used by Robert Williams, explains the situation and the student's options very clearly.

But Do I Have to Go to Our School's Contract Photographer?

Remember your freshman and sophomore pictures? Do you want a photograph like that to be the one that all of your friends remember you by? Well, the contract photographer is probably the one who cre-

ated those "gems." And guess what—your school may try to force you to use them again!

Don't be misled. Having your school tell you where to buy your senior portraits is like your school telling you where to buy your prom dress or rent your tux. They simply shouldn't do it! Some schools send out flyers, which, at a glance, imply that the contract photographer absolutely must photograph you or you will not appear in the yearbook. But read the fine print—usually they also say, "If you are photographed by another photographer, you must have the yearbook pictures submitted by such-and-such date, and it must be exactly to our specifications." They try to make it sound really threatening and intimidating.

The truth is that printing a yearbook photo exactly as they require is as simple as writing down the

specifications correctly. We do it every day, all summer long, for nearly every school in the area.

If the school is really strong-arming you into using the contract photographer, you still have a choice. You can let the contract photographer take your yearbook picture without being obligated to buy anything. You can then come to Rice Photography for the senior portraits that you really want and know you'll be happy with!

Don't be misled. You have a choice!

Ohio photographer Russ McLaughlin handles the questions about contract photographers this way:

Whoa! Who Said You Had to Go to the School's "Contract Photographer" for Your Personal Portraits?

Let's clear up the confusion about "official" or "contract" photographers. Although we are not the contract photographer for your school, or any other school for that matter, we can take your senior portrait for use in most school yearbooks. Some schools will not accept senior portraits that are not taken by the contract photographer. In these instances, we will take your senior portrait for your personal use and discount the session fee to compensate for the fee you will be charged by the school photographer for your yearbook photo. Remember, the school may have a contract for services with a certain photographer, but the photographer has no contract with you, and you have no purchase obligations to that photography studio.

Russ takes a very proactive approach that takes away any excuses that a student or their parents might use to justify hiring the contract photographer, leveling the playing field somewhat. He has effectively eliminated any financial loss that they would incur by choosing him.

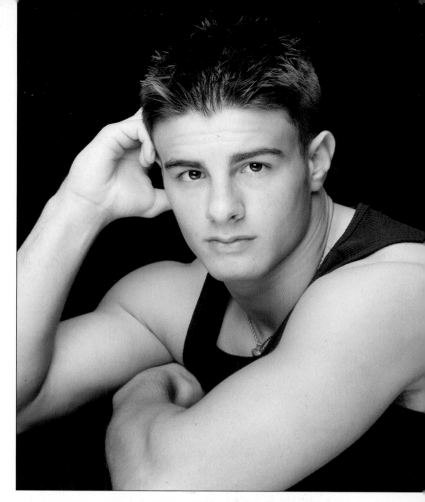

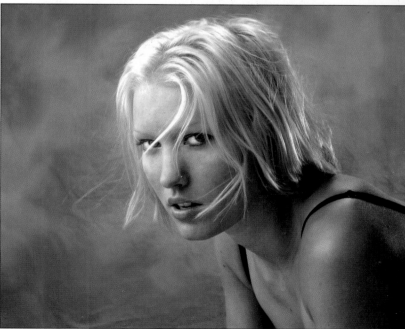

Black & white images have an edgy appeal for today's seniors and can figure prominently in select marketing pieces. Top image by Leonard Hill. Above image by Kathryn Sommers.

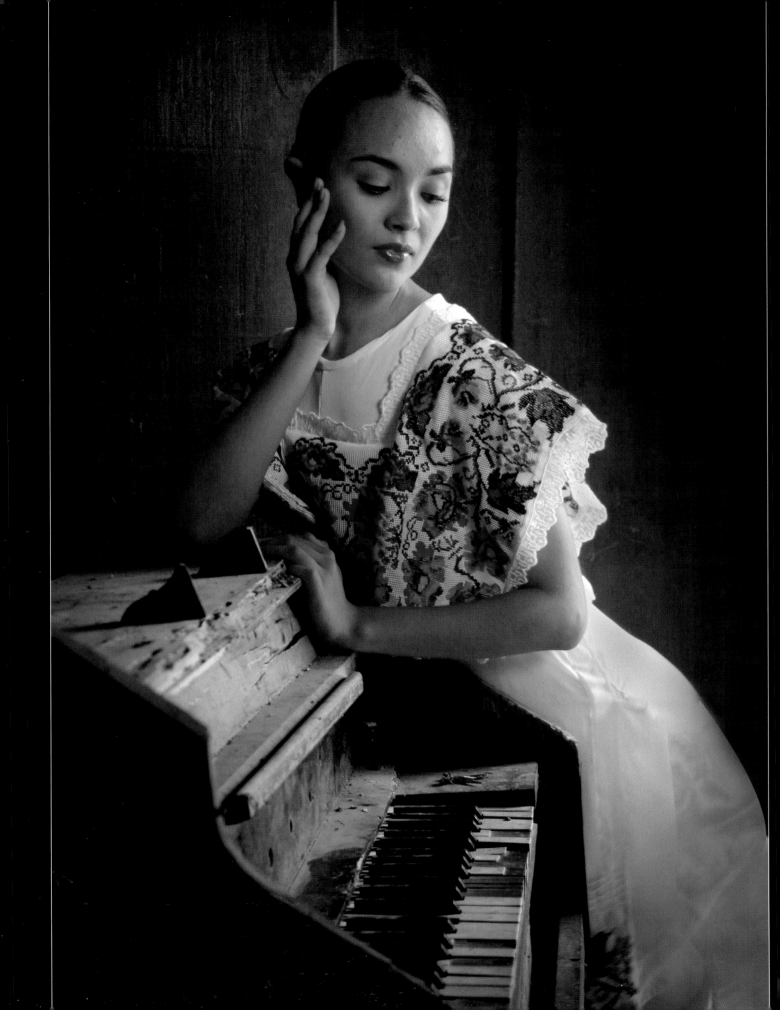

Personalizing the Session

Personalizing the session for teems and seniors leads to greater client satisfaction and bigger sales. In this chapter, we'll take a look at some of the ways in which you can tailor the session—and the resultant portraits—to suit your client.

○ THE CONSULTATION

There are two occasions when we have a consultation with prospective clients. First, for students interested in our "model" program (see pages 102–5), we have a mandatory consultation with the senior and at least one parent. This PowerPoint presentation showcases our images and accomplishments in photography and provides general information about the studio. The presentation also explains what the program entails. We show the benefits of the program to the student and the potential cost savings and monetary incentives that can be achieved.

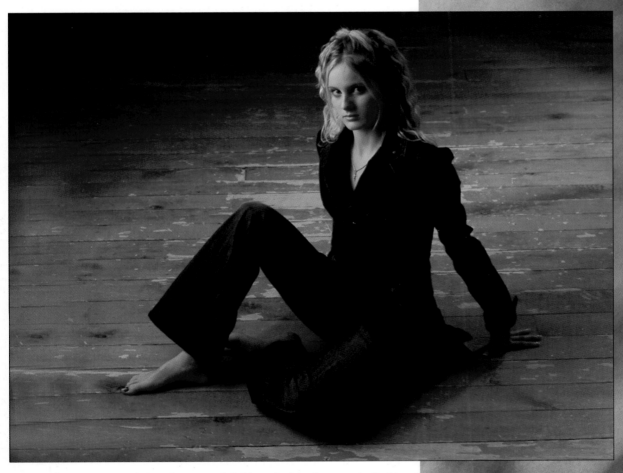

A well-informed client can help make prop and clothing selections that ensure a positive portrait experience and fabulous photos. Facing-page image by Monte Zucker. Above image by Dennis Valentine.

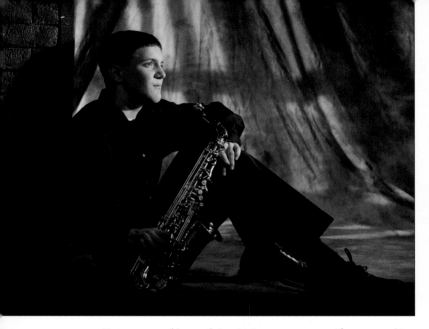

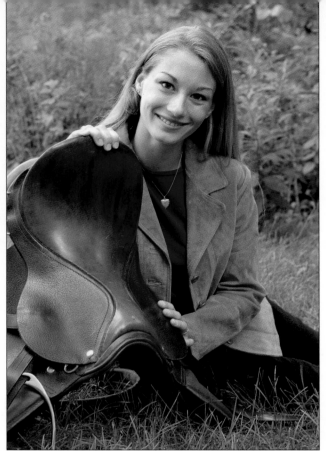

Encourage students to bring in instruments or uniforms—anything that will help to portray their interests. Above image by James Williams. Right-hand image by Michael Ayers.

A second type of consultation is scheduled with prospective clients who want to check out our studio before scheduling a portrait session. These clients are shown 8 x 10-inch images in a black General Products 600 series album. In addition, they will see images from past high school seniors in the General Products Ellie Vayo Senior Albums as well as 8-up and 16-up folios. We also have several large images hanging on the walls of both the studio and camera room for prospective clients to view.

○ CLOTHING

While seniors may think a lot about clothing, no photography studio should ever make the assumption that all high school seniors know what to wear for their portrait session. It is up to the studio to educate the client about what would work best in their portraits. Prior to every session, we mail out a flyer to help seniors with clothing, makeup, hair, etc. This idea stems from promotional pieces created by both Ellie Vayo and Steve Ahrens.

Tips for Looking Great in Your Senior Portraits

As the summer nears, high school juniors will begin to think about their senior portraits. Senior portraits are one of the most memorable and special moments of your high school career. You will want to look your very best. As you prepare for your portrait session, keep the following tips in mind.

CLOTHING AND ACCESSORIES
- Clothing can reflect your personal style and attitude—choose whatever you feel is appropriate.
- Pick clothing you are comfortable in.
- Dark clothing tends to be more slimming.
- White will look good for a high-key effect, but it does tend to "widen."
- Don't forget formal attire (suits or dresses) for a classic portrait.
- Be sure to select undergarments that are well suited to the outfits you plan to wear during your session.
- Bring in sports uniforms, varsity jackets, and band uniforms.
- Don't forget to accessorize—belts, ties, jackets, hats, necklaces, and earrings will enhance the portrait.
- Musical instruments and sporting equipment can personalize your portraits.

MAKEUP AND GROOMING

- Natural-looking makeup is best. Wear your make-up as you normally would, but accent your lips and eyes a little more than normal.
- Bring in your eye makeup, lipstick, and cover-up for last-minute touchups. For an additional fee, you can obtain the services of a trained makeup specialist for your sitting.
- Do not try a new look for your portraits.
- Double check for chipped nail polish and well-groomed eyebrows.

HAIR, SKIN, AND GLASSES

- Arrange your hair in your favorite style, using hairspray to keep the outline of your hair smooth.
- Have your hair cut and/or colored at least a week prior to your session.
- Watch for sunburn! Tans look great, but sunburns do not. Redness cannot be removed, and tan lines can only be removed with extensive digital retouching at an additional cost to you.
- Try to mask blemishes as much as possible with cover-up before the session—the rest can be dealt with by simple retouching at no additional cost.
- Glasses can both create glare in your portraits and distort the shape of your face. It is best to remove the lenses or borrow a pair of frames without lenses.

Correcting any perceived flaws before the portraits are taken will make your final images appear more natural and save you money. By following these tips and sticking to what is most natural and comfortable for you, you will assure yourself of a successful sitting and great portraits that you will be proud to share with your friends and family!

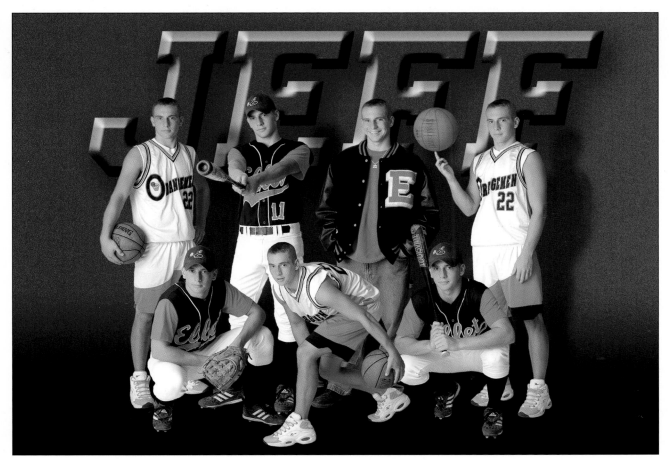

Digital imaging makes creating composite images like this one a relatively simple task. Image by Robert Williams.

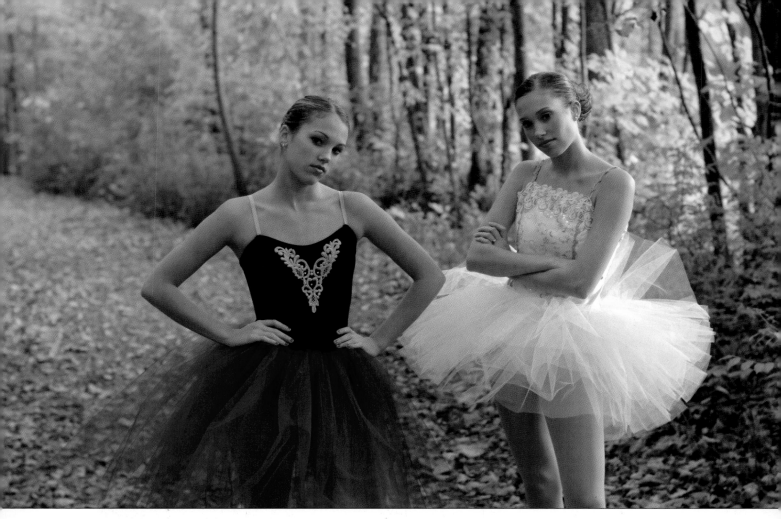

Outdoor locations can add appeal and diversity to the photo session. Image by Michael Ayers.

○ CATERING TO THE CLIENT

With high-school senior photography, making the portrait experience fun is just as important as the images themselves. Today's young adults are savvy consumers. They make buying decisions based on what they believe is fashionable as well as being a good value. There is nothing quite as persuasive as a minimum-wage job to make a person cost conscious.

Style is of the utmost importance. Each high school senior has his or her own unique identity. They don't like to be categorized or labeled in any way. This is an important point for any photographer in this business. Even though we may tend to stereotype these students, you can never elude to them in that way. Each student is looking for a photographer who will take the time to get to know them and create images that are a reflection of their unique personality. Not surprisingly, most of the students that

we talk to have relatively low expectations for their high-school senior portrait session. Most feel it will be tedious and no fun at all. The seniors we photograph are very pleasantly surprised by the individual attention that they receive. We take the time to talk to each senior. We find out where they work, what activities they're involved in, where they plan to go to college, what they hope to do upon graduation, etc. We treat them like adults. We ask questions and then let them talk. We listen to them. I cannot stress enough how important that is to each of these young adults. I think that they feel that nobody listens to them or takes them seriously. It is not that way at our studio, and the students leave knowing that.

It is funny how the little "extras" can impact each senior you photograph. When a student or their parent calls to set up a time for their senior photography session, we make certain that we have the correct

spelling of the student's name as well as their home address. We send out two reminder postcards to each senior prior to their session. The first postcard is sent out the day after they set up the appointment, and the second is sent out just prior to the actual appointment date. Like many studios, we have a welcome sign outside the studio door that we can personalize by listing each senior's name on the day of their session. The students feel like they are more than just a number when they see their name on that sign. We take this same idea one step further by having a framed nameplate on the dressing-room door and a gold star just above it, much like the one that Hollywood celebrities have on their dressing-room doors. Jim Williams shared this idea with me, and I have also seen this used at the studios of Ellie Vayo and Robert Senn. Again, the students love the personalized attention—some students have even asked to be photographed by the door with their name on it and even take the sign home with them after the session. Inside the dressing room there are a variety of hair care products (including a curling iron), a spray bottle full of water, and a steamer, iron, and mini ironing board. Like Ellie Vayo, we even have a framed sign that reads:

Please feel free
to use any of our
personal care products.
If you need something
but don't see it,
just ask us!

Photographer Kalen Henderson has a little goody bag waiting for the senior in their dressing room—an idea that we incorporated in our studio as well. We

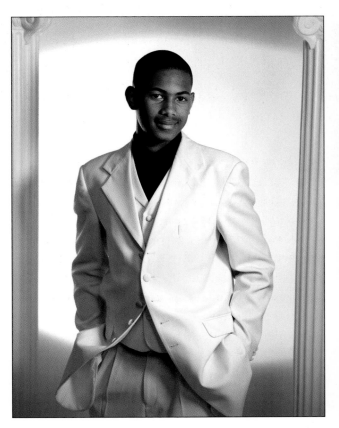

Above—Classic clothing can be worn to ensure an image with enduring style. Photo by James Williams. *Right*—A goody bag, printed with our studio logo and filled with treats, awaits each student in their dressing room on the day of the session. Image by Patrick Rice.

Using student surveys can help you to hone in on the style of image your client is after. Images by Scott Gloger.

use a high-quality gift bag with rope handles and our studio name on the outside. Inside the bag are a bottle of water, some chocolate, mints, a plastic comb, and a handwritten thank-you note to the student. Kalen also includes a lanyard with the studio logo imprinted on it. This is a great idea since many schools now require their students to wear ID badges on school grounds.

Another step we took to enhance the students' portrait experience was to add XM satellite radio in the camera room. Again, both Jim Williams and Ellie Vayo have done the same thing in their operations. Everyone loves it, and we no longer need to try to buy countless CDs to keep up with what is popular at the moment. There's no more tuning in to a radio station only to hear a terribly inappropriate commercial between songs. Satellite radio is commercial free, and there are over 100 stations to choose from that each specialize in a particular genre. It has become such an important feature at our studio that students are telling their friends what stations to tune in to when they come in for their portraits.

Don't think for a minute that these little touches go unnoticed. Don't think that the seniors don't mention these things to their friends. As Jim Williams always tells me, "It's the 'sizzle' that sells the studio."

○ STUDENT SURVEY

It is sometimes difficult to get information from timid teenagers that will allow us to help them personalize their portraits. To this end, we created a survey to find out what special interests might apply to each senior. This form only takes a few seconds to fill out, but it has really helped us to know what elements to integrate into their photographs.

Senior Interests Survey

Do you participate in any of the following sports? (check all that apply)

- ❒ Baseball
- ❒ Softball
- ❒ Football
- ❒ Basketball
- ❒ Soccer
- ❒ Tennis
- ❒ Racquetball
- ❒ Golf
- ❒ Hockey
- ❒ Volleyball
- ❒ Boxing
- ❒ Martial Arts
- ❒ Skateboarding
- ❒ Other (please specify)

Do you play any of the following instruments? (check all that apply)

- ❒ Acoustic Guitar
- ❒ Electric Guitar
- ❒ Violin
- ❒ Other (please specify)

Please list any other interests, hobbies, or themes for your photographs:

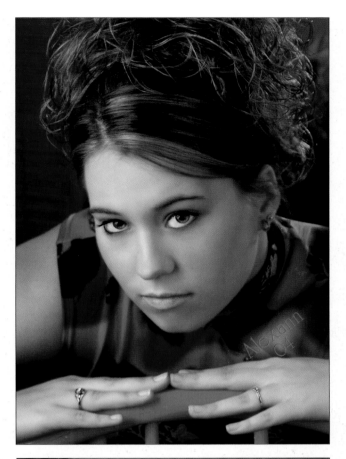

Top—Be sure to capture a variety of moods during the session. While many parents may prefer to see their child's smile, teens often like images with an edgier, more mature feel. Image by Dennis Valentine. ***Above—***Your clients' portraits freeze a moment in time—and that's why many seniors choose to incorporate meaningful props in their photos. Image by James Williams.*

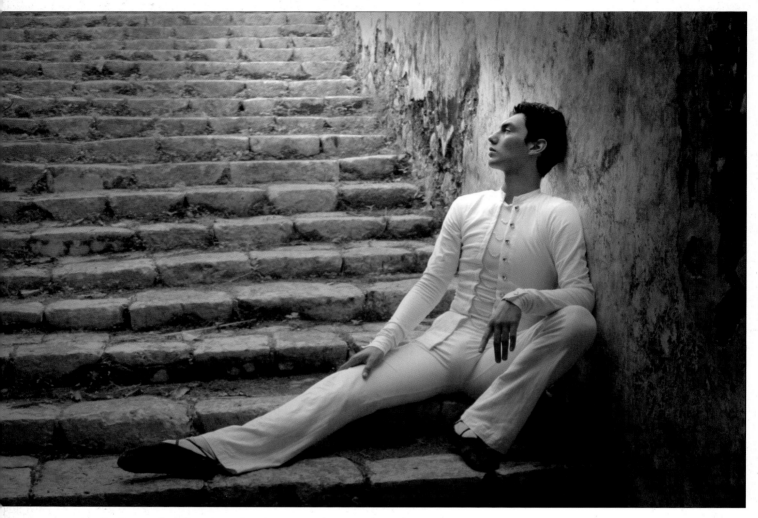

You can use the LCD on your digital camera to show your clients their images as you work. When they see how great their images look, many students will begin to relax and may get more enjoyment out of the session. Above image by Monte Zucker. Image on the facing page by Barbara Rice.

O STUDENT FEEDBACK

We want each student to be excited about their portraits before they even see their prints. Digital photography has been an incredible tool in accomplishing this goal. With digital, I can show the student the images on the camera's LCD screen immediately after they are recorded. This reassures the senior that they will love their photos. If they are not completely happy with the images, I tell them that I will gladly delete them and shoot again. This, of course, was never possible with film. Some studios in our area have taken this concept one step further by having their camera tethered to their computer and having each image appear instantly on a large television monitor that can be viewed by the senior. This adds tremendously to the "wow" factor of the senior experience, although it does tend to slow down the session. We were unable to accommodate a monitor in our shooting area, so we show students their images on our desktop computer immediately after the session. We load the CompactFlash card into the card reader and use our Fuji StudioMaster Pro software to present an instant slide show and also compare images side by side on the screen. Each senior knows they love the images even before we make their prints.

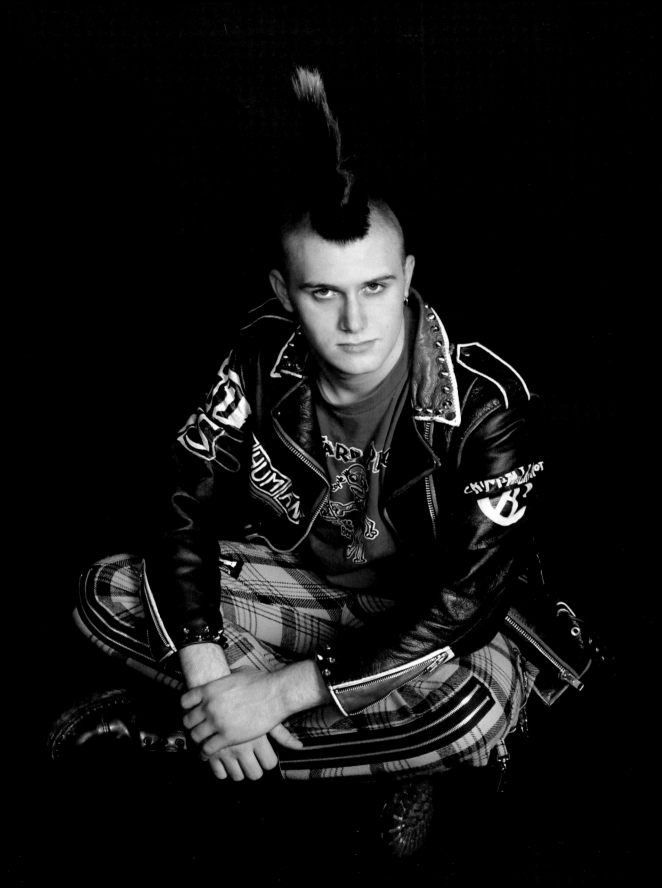

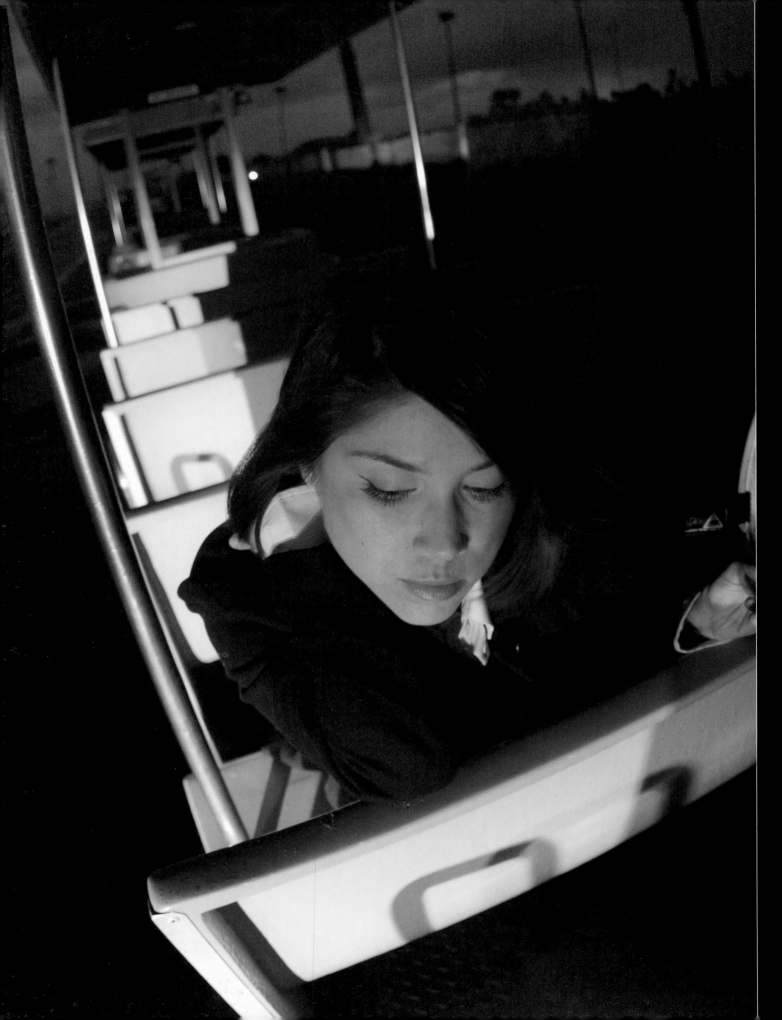

Creative Sets, Backgrounds, and Props

Choosing the right sets and props can help you to create high-style images that will grab prospective clients' attention and drive your business.

O STANDARD PROPS

The right props can impact a studio's success. Fortunately, there are numerous companies that can accommodate the needs of any studio. There is not enough space in this text to list all of the props that can be used for teen and senior photography; however, I will discuss some of the better and more popular options below.

I certainly cannot have a discussion about senior photography props without mentioning the standard props: the big, graphic, three-dimensional ones that say "senior" or the numbers of the graduating year (say, "2012"). Let me start by saying that at our studio, we do not buy the year numbers each season. Instead, we imprint the year on most of the students' wallet images. We do own a vertical, Styrofoam "senior" prop that we have had for nearly twenty years, but we don't use it very often.

Posing stools and tables are considered essentials for most portrait photographers. Columns and blocks are also found at most studios, as are a variety of chairs. Other props used are determined by the photographer's personal style and taste. We use a 2 x 4-foot Plexiglas mirror to have the student rest on and to reflect their image. There is nothing new or unusual about this item, but it seems to remain popular throughout the years.

Posing grids are also popular with many photographers. These multiuse grids measure 24 x 84 inches and can be used as a background for displaying school jackets, uniforms, or other items.

O SETS

The emergence of specialty prop companies such as Off the Wall and Scenic Design is a relatively recent but welcome phenomenon. These companies have made theatrical props and set designs available to photographers worldwide. These lightweight props are easily moved around the studio and can even be stored outdoors. Although they are very expensive, they give an unmatched realism to the set. The high cost can be a benefit for some photographers too, since other studios may not have such sets in their budgets.

Facing Page—Whether you create the majority of your teen and senior images on location or at the studio, using creative props, sets, and backgrounds will help you set your images apart and command higher profits. Image by Lisa Smith.

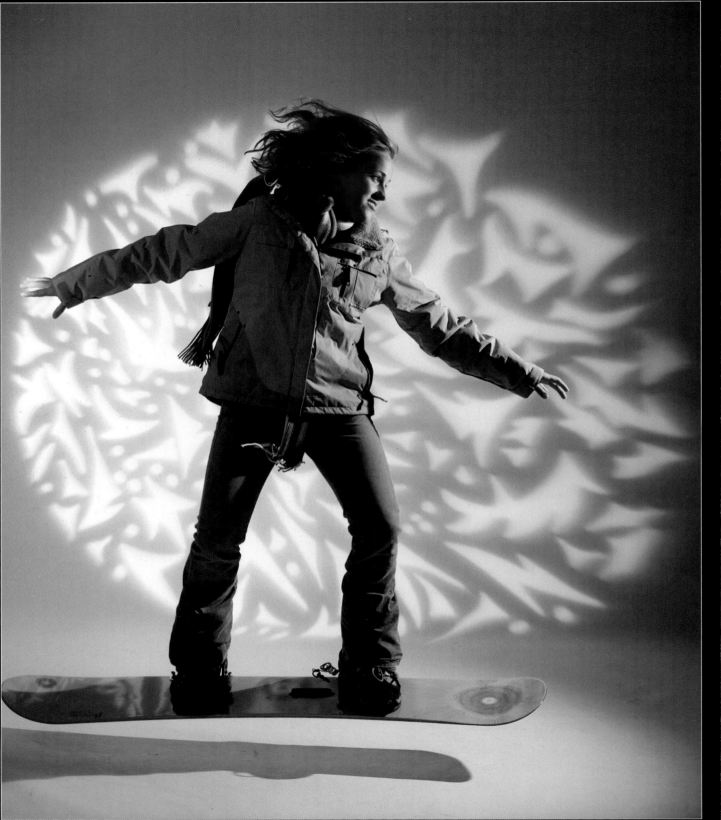

Facing Page and Above—*Today's seniors will shop around for images that suit their personality Facing page image by James Williams. Above image by Dennis Valentine.* **Right**—*This Off the Wall set adds dimension and visual appeal to the portrait. Image by Barbara Rice.*

We own three complete Off the Wall sets, various props made by that manufacturer, as well as several props from Scenic Design. When these sets first hit the market, there were few set choices, and many of the leading studios purchased them. Now there is a wide selection, with new styles being made available each year. Because most local studios don't own these expensive sets, we have a competitive advantage in the senior photography market.

○ PROFITABLE PROPS

Having discussed many of the more common, yet necessary, studio props, I feel it is important to share some suggestions about the more unique props for teen and high-school senior photography.

Thousands of photographers flock to conventions that are widely attended by suppliers who sell backgrounds and props to studio owners from across the country—and probably in your market area. No matter how "cool" a particular prop may be, if several photographers have the same thing, owning the particular piece will not set your studio apart. I recommend that photographers look for props from less conventional sources to make their images more exclusive.

I am always looking for unique or unusual items that can be used in our portraits. One of my favorite sources for unique items are antique stores. Antiques, by their very nature, are uncommon. Old

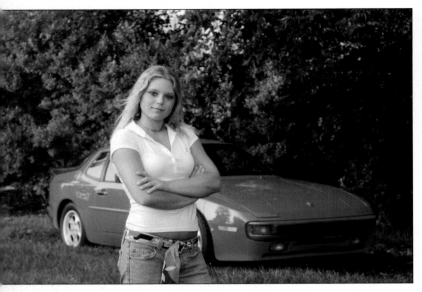

*Left—Handcoloring the Porsche in Photoshop gave this photo an added edge. Image by Barbara Rice. **Right**—My red Porsche 944, with the "senior" license plate, is a popular prop with many students. Image by Patrick Rice. **Facing Page**—Image by Ken Holida.*

chairs are certainly my favorite antiques for use in photography. I have a gorgeous old chair that is very elegant and works well for a formal portrait. I have also purchased simple, structurally sound wooden chairs that had a poor appearance. We have painted these chairs in different colors to coordinate our students' different outfits. This is both an inexpensive and unique prop that can add dimension to many portraits.

While most of the antiques that I have used are small items that I picked up to add to a particular set, some photographers I know have built entire sets around a couple of key pieces. One of the most common examples that I have seen is an old Coca-Cola machine or cooler. These large red-and-white machines are durable enough for clients to sit upon or lean against and give portraits a retro feel that is very popular with today's students. Very large round or rectangular metal Coca-Cola signs can also be added to these sets to provide more depth in the photograph.

Floral supply shops are another great resource. These supply houses sell many items that photographic props suppliers offer—but substantially cheaper! I have purchased white, lightweight columns and railings at the florist shop that cost 25 percent less than what the photo supply store was asking. Because these props are popular in our industry, we buy a stone-look texturizing paint to add color

and texture to these items. The paint comes in a spray can and can be found at craft shops, building-supply centers, and some department stores.

Room dividers are another favorite. These can be purchased at antique stores, furniture stores, home decor–type stores, etc. They come in a variety of materials, including wood, wicker, wrought iron, plastic, and even cloth. These dividers give the student something to stand next to, lean on, or just have in the set to add depth and dimension. You can even make your own with large shutters and some hinges.

I am very much aware that my competition acquires our promotional pieces to see what we use and how we are using it. I decided to raise the bar by having a prop that they (to this point) are unwilling

Speak to your accountant to determine whether you can take a partial or full tax write-off for cars used for portrait purposes. Image by Michael Ayers.

to invest in. My favorite studio prop is my show-quality, red Porsche 944 automobile. Many senior photographers I have met have sports cars, old trucks, and/or motorcycles that they use routinely in their photographs. Each of these vehicles provides a unique prop that students (especially high school seniors) can be photographed with. Most photographers with a vehicle for a prop have Chevrolet Corvettes. Although these are indeed beautiful cars and are very popular, I felt they were almost too common. I remembered that photographers Larry Peters, Walter Rowe, and Ralph Romaguera each had foreign sports cars. I liked that idea, and when the opportunity arose to acquire an older Porsche, I knew right away that I would be able to use it for photographs. I now use the Porsche in as many of our high-school senior sessions as possible. Since we use cars in our photographs on a regular basis, I had a custom license plate made from www.engravenet.com that simply says "senior" in script type. This is now attached to the front of the vehicle's real license plate with a piece of double-sided tape.

Each student is asked if they would like to be photographed with this sports car. Though some students choose not to do so, most are thrilled to have their portraits taken next to a Porsche. I see the Porsche as another symbol of success that these young adults hope to achieve in their careers. To them, this is no different than designer clothing; the car helps them to cultivate an image they are trying to portray.

Understand that my Porsche is only partially a business write off. I spoke with my accountant prior to my purchase and was advised on the tax benefits of the vehicle. In short, for a vehicle to be legally written off, you must prove that it is actually used for business purposes. The IRS looks very closely at any purchases it may deem to be unnecessary or exces-

sive. Whether you want to partially or completely write off the cost of any vehicle you purchase, the burden of proof lies with you.

Photographs that feature the Porsche are used in many of our promotional pieces as well as in studio samples and on the website. This usage helps to justify to the IRS the legitimacy of the partial write off.

○ PROPS EXCHANGE

Many of the major sets and props that studios invest thousands of dollars in become less appealing if used year after year. Through networking with non-competing studios, many photographers have found they can "trade" props and sets for a period of time to give their images a fresh look. Since no money is exchanged, the only expense is transporting these sets and props to each other's studios—a small price to pay compared to the cost of purchasing such items.

Studios are even exchanging backgrounds. Many studios that photograph school dances have to create a new set every year to keep the students from getting bored with the studio and looking for a new photographer for the following year. Many of the backgrounds used in this set are quite large (up to 10 x 20 feet) to accommodate full-length portraits and can be very expensive. Further still, the accompanying props that give the portrait a three-dimensional look can be costly. By trading with another studio, the photographer can net much more of the proceeds from the school dance.

○ STANDOUT BACKGROUNDS

Besides all of the commercially available backgrounds that you can purchase, you can also create some of your own designs. An idea that I originally saw at photographer Jerry Clay's studio is a compact

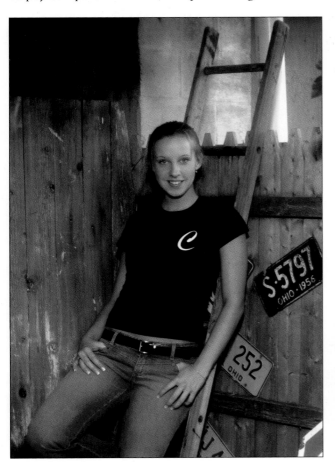

Left—This simple set has teen appeal. Image by Ken Holida. **Right**—This sports-page background was easy to construct and inexpensive too. Image by Patrick Rice.

disc wall. To create this background, I purchased a 4 x 8-foot sheet of building insulation material at the local building supply store. This sheeting is available in several thicknesses, from $^1/_2$ an inch to 2 inches, and has a silver covering on one side. I chose the 1-inch thickness for durability. The material is foam-based, so it has very little weight. For the CDs, I went to local electronics stores and picked up all the free Internet provider CDs that I could find. With a tape gun loaded with double-sided tape, I applied each CD facedown onto the silver side of the insulation. There is no exact pattern to how I placed the disks—I just glued them on randomly, overlapping them until I covered the entire surface of the insulation. The background has a very contemporary look, and the silver discs reflect all of the color in the studio. We usually photograph the senior right up against the CD wall and shoot the image from an angle so as not to get a reflection of the lights in the image. It has been very popular at our studio.

On the back of this insulation board, I created another distinct background. I used my tape gun to randomly adhere several days' worth of the newspaper's sports section to the board. This sports-page background is now used with many students who participate in a variety of sports. The interesting thing about this background and the compact disc wall is that the insulation board only cost about $12, and yet, with a little bit of effort, I was able to create two inexpensive, yet profitable, backgrounds that most of my competition cannot offer.

Since the "retro" look is becoming very popular in clothing worn by today's teenagers, I used this same type of insulation board to create a record-album background. Since I no longer own any records, I went to the local Goodwill store and bought some for 25 cents each. It did not matter to me who the artist was that recorded the album, what I was looking for was a variety in colors in the center label of the 12-inch records. Again, with the double-sided-tape gun and adhesive, I simply mounted the records to the black side of the insulation board. Many of our high school seniors have chosen to use this background instead of the CD background.

Top—This background was easy to create using CDs. Image by Barbara Rice. **Above**—*This CD-artwork background was created on the other side of the CD wall. Image by Patrick Rice.*

On the backside of this same insulation board, I created a background using CD cover art. In every CD there is an insert or booklet with the name of the artist and the title of the recording. There are sometimes also interesting images of the artist throughout the booklet. I simply cut up all of these inserts and meticulously adhered them to the silver side of the insulation board. Most of these CD inserts are printed on highly reflective glossy stock, so when I was finished gluing each of these on the board (some 230 of these 4³/₄-inch squares) I sprayed the entire board with clear matte spray paint so the squares would not reflect the lights as much. This background is very popular with our seniors.

Many studios now offer some type of patriotic or American flag background. We took this one step further by acquiring the largest American flag that I have ever seen, 20 x 40 feet! I actually purchased this flag at a garage sale from a retired vice president of the largest bank in town. This bank's headquarters are in

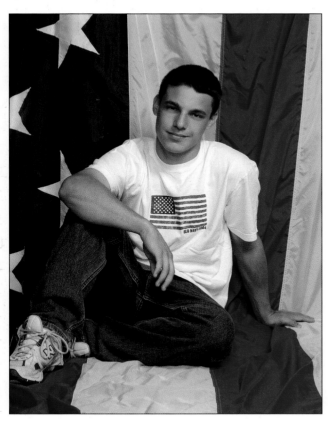

Our 20 x 40-foot American flag is a hit with our clients. Image by Patrick Rice.

a massive skyscraper that bears its name. As a tribute to this VP, they flew this flag on top of the building on his last day of work and presented it to him at his retirement party. He had no practical use for it, so he sold it to me for $40. It is very impressive, and our students are amazed when they see it. Each star is about the size of your face! We describe this background as the largest American flag anywhere, and it is used often in our portraits.

⊙ HAND-PAINTED FABRIC BACKGROUNDS

While there are numerous companies that offer painted backgrounds, Les Brandt Backgrounds really do sell themselves. The backgrounds that are individually and meticulously painted by this small Midwestern company are some of the most incredible that I have ever seen. The realism and dimension captured on either canvas or muslin is truly without comparison. We have been mesmerized by some of the offerings in their Super Scenic collection. More importantly, the students' reactions to these backgrounds have been beyond belief. We find that when the senior sees how elaborate and unusual the background is, they *want* to be photographed in front of it. They show their appreciation by telling their classmates about it, and their enthusiasm is contagious.

Our first Les Brandt investment was a background called "The Horse." My wife Barbara, being a horse owner and rider, was drawn to this background, although she was initially taken by the rich colors and patterns. Viewing the entire 10 x 20-foot background, you can see the majestic painting of a powerful equine in full gallop. This background is painted with layers of cool tones and works well with both the males and females. As interesting as the overall scene is, I love the way we can just use sections of the background to introduce color and design elements into our portraits.

Our most recent Les Brandt background is called "Thunder Road" and features a chopper-style motorcycle with its tires spinning. Certain to have strong appeal to both high-school senior boys and girls, it also has great color and design elements for closer work. Also, the overall warm tones of this background

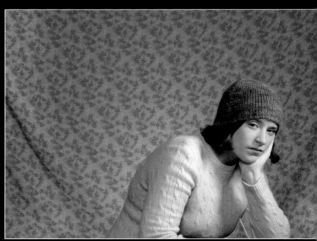

Top Left and Bottom Left—"The Horse" and "Thunder Road" are two popular backgrounds available from Les Brandt. Top-left image by Barbara Rice. Bottom-left image by Patrick Rice. **Top Right**—Fabrics make inexpensive backdrops that can be coordinated with your clients clothing. Image by Patrick Rice. **Above**—Image by Barbara Rice.

make it the perfect complement to "The Horse." Although these backgrounds are not inexpensive, I feel they are a worthwhile investment and help to make our studio stand out in the competitive senior photography market.

○ THE PORTRAIT PARK

At our studio we have a very extensive outdoor portrait park. In our literature describing this park, we mention the different props and sets that we have available for photos. This is one of the ways we try to differentiate ourselves from other studios in the area.

Although we have very little property to work with (less than 1/3 of an acre), we have maximized the space to our full advantage. We create "street scenes" with the use of old, distressed doors—covered in cracks and peeling paint—that were purchased from a local antiques store. These three doors (two different white doors and one green door) are used to create a portrait with an urban look. Each door was simply attached to the wooden fence that lines the property. The doors only cost about $20 each, yet they have generated thousands in sales.

One of the most popular areas in our outdoor portrait park is our tropical beach set. This particular set has both permanent aspects as well as portability. We hang a 10 x 20-foot painted muslin beach background, fitted with grommets, against the side of our building. The background, from Backdrop Outlet, is a beautiful tropical scene with a painted blue sky and

The major components of our beach set can be used indoors or out. Image by Patrick Rice.

a tall palm tree on it. For outdoor use, we simply tuck the "sand" portion of our mural out of sight and use a faux sand substance that complements the scene. I didn't want to use real sand because it would stick to my clients' shoes and end up in our studio. As an alternative, photographer Ellie Vayo recommended that I purchase stone called pea gravel from a local building supply store. These very small round stones come in a mixture of earth tones and photograph just like sand without the mess! The pea gravel covers an area about 12 x 12-feet wide in front of the hanging muslin background. We then added real wooden pilings from Denny Manufacturing to give the students something to lean against or stand next to. A local floral supply company, Flower Factory, Inc., was my source for silk palm trees. We placed two and three palm trees on either side to give added depth to the photograph and coordinate with the palm tree painted on the background. To make the seam between the background and the pea gravel appear believable, we mounded the stone a couple of inches higher where it meets the bottom of the background and placed fishing net and driftwood on top of the mounded gravel. The finishing touch was to add real seashells, a conch shell, and a starfish (of course, this set can be personalized as you like). The painted muslin background is taken down every day after sessions, and if it is raining (or snowing) on the day a photograph is scheduled, we hang it in the studio and bring the piling, fishing net, and shells indoors to complete the set. I feel the set works better outdoors, not because the images are better but because of the way the students react to the set. Inside, the beach background is just another pretty background. However, when the students see this elaborate set outdoors, they seem to imagine that they really are in the tropics—not Cleveland, Ohio!

We have a functional rustic red storage barn in which we store all of our landscaping and maintenance tools, and it doubles as a background for a more Western-style portrait. All studios need a building to hold items of this type as well as prop storage, and traditional aluminum or plastic storage buildings have no photographic appeal. I never want to

Left—Our storage building makes for a rural-inspired image. Right—This portrait background shows an area of the waterfall set. Images by Barbara Rice.

pass up an opportunity to add a secondary use if it is possible.

Our biggest undertaking in our outdoor park was the creation of a waterfall set, which centered around two plastic tub ponds that I had purchased. We took a corner of the property adjacent to the rustic wooden storage barn and decided to completely fill that space with this set. Obviously, to make a waterfall you need to maintain a large supply of water and a pump system to force the water back up to the waterfall's highest point. We discovered you need a very strong, commercial-grade pump to force enough water to make a waterfall and not just a trickle of water. Having the two key pieces of this set, I then created a foundation with cinder blocks—97 of them, to be exact. I wanted a solid set that would be very low maintenance and easy to build. I could have brought in several yards of dirt, but I was concerned about it settling and becoming a repair problem in a

short period of time. Concrete was poured into the cinder blocks for reinforcement, and large flagstones were cemented on top of the cinder block to create platforms and steps. Dirt was then added around these steps and platforms so that we could "plant" some artificial greenery, making it usable year round. This is probably the single most important element of the set besides the waterfall itself.

Recently I decided to remove all of the grass in our primary outdoor park and replace it with #57 river rock. These stones are brown and beige in color and photograph well with all of the sets. However, the primary reason to replace the grass with rock was so

we could still use the outdoor portrait park after heavy rainstorms. Many area photography studios cannot use their outdoor settings just after the rain because of large amounts of standing water. The #57 river rock drains almost instantly, so we can photograph outdoors just after and even during the rain without everyone splashing around or sinking in the mud.

We have an open field adjacent to our property along a natural green hedge line where we can photograph students with their cars, trucks, or motorcycles. On the other side of the field there is a brown wooden retaining wall that can also be used as the backdrop for vehicle images.

There are a number of smaller set elements that we use for our senior portraits. These particular pieces allow us to add increased versatility in our outdoor park and give seniors more options. These sets are most often used when photographing female clients.

Our park bench is the typical bench that is available at any building supply or landscaping store. It has wrought iron side pieces with wooden slats to sit on. This is used primarily with female clients for seated portraits. We also have a faux marble bench from Off the Wall Productions. It is very realistic in appearance yet weighs very little so that it can easily be moved in front of other props and structures for some photos. We also have an authentic, stationary marble bench that is placed in front of a flower garden.

We use some trellises for some senior photographs—almost exclusively with the females. We have a dark-wood corner trellis that is permanently affixed in one corner of the property. It is triangular in shape with a wood seat and lattice sides. It stands about 8 feet high. For some sessions, we will lace silk flowering vines through the lattice to match a particular outfit the senior is wearing.

Another versatile outdoor set is a white wall, made of a section of 6 x 6-foot white PVC stockade fence. We enhanced this set with a 8 x 6-foot white PVC arbor as well as two sections of 3-foot high white PVC picket fencing. The arbor and picket fence can be quickly and easily removed from the set depend-

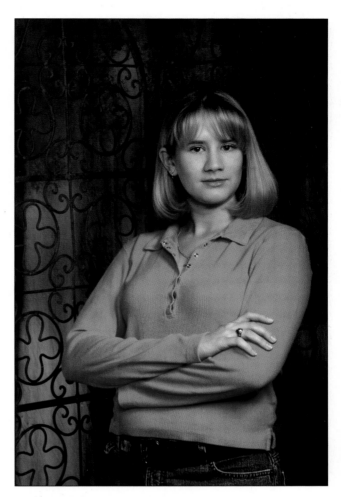

Our trellis set is popular with many female clients and lends a classic look to portraits. Image by Barbara Rice.

ing on the type of image we are creating. We also use a white Adirondack chair with this set in many of our senior sessions.

We also have a white plastic lattice that we use in front of our white wall set. This prop is available at most home improvement stores (Lowes, Home Depot, etc.) for under $100. We sometimes place two white plastic picket fence sections (about 3 feet high) in front of the senior to add dimension to their images.

A wrought-iron gate can be a great graphic element in a senior portrait. Ours has double swinging "doors" that are sandwiched between two sections of matching fencing, and together span about fifteen feet. Built into this set element is also a trellis that envelops the gate.

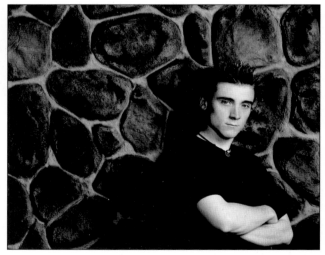

Above Left—*Our iron gate is a vital component of our outdoor set.* *Top Right*—*An Adirondack chair is a simple addition to our white wall set. Images by Patrick Rice.* *Bottom Right*—*Our stone wall adds texture and an edgy look to our portraits. Image by Barbara Rice.*

Our stone wall was hand constructed by myself and Chad Tsoufiou, another photographer at our studio. The property already had an existing 4-foot high wooden fence, so we decided to attach the stone wall directly to it.

On either end of the wall, we anchored a 10-foot steel fence post into the ground 2-feet deep in concrete. We then bolted 8-foot tall 4 x 4-inch wood posts to the existing fence and also to each other. The two end pieces were attached to the steel fence posts. This created a very solid wooden wall 8 feet high and 10 feet across, to which we adhered facing stones with mortar. These facing stones are real rock and are very heavy although they are only an inch or two thick.

Once complete, we had an authentic rock wall that works very well for both males and females. It is one of our seniors' favorite backgrounds, and in our area, it is exclusive to our studio.

No matter the specific props you select for your outdoor park, it's important to keep in mind that the

The Outdoor Portrait Park
At Rice Photography

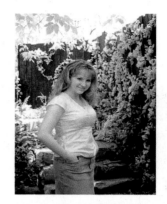

At Rice Photography, you have the convenience of having an outdoor portrait park right on the premises. There is no need to drive off to some public park that affords you no privacy like so many studios in the area. Do you really want everyone at a public park watching you as your senior photographer is trying to create your portraits? Do you realize that you will probably only be photographed with the clothes that you would wear to the park? I mean, really, are you going to change clothes in your car? In some smelly public restroom?

We feel you deserve better than that. At Rice Photography, every outfit you bring can be photographed both inside on our elaborate sets and backgrounds and outside by our many natural and custom sets. You only have to walk out the back door of the studio to get to our park. This will save you a considerable amount of time and give you much more variety in your senior portraits. Our outdoor settings include three different trellises, a stone pond with waterfall, an iron gate, a western set, a stone wall, a park bench, barns and street scenes.

We also have the space at the studio to photograph you with your car, truck, bike or motorcycle. You can even choose to be photographed with our show-quality Red Porsche sports car. No other studio can offer all of this – and its included at no extra charge in most sessions! How can you go wrong? If you are looking for senior pictures that offer more than the ordinary, call Rice Photography at (440) 979 0770. You'll be glad you did!

maintenance of an outdoor park is often overlooked but nonetheless important. Once a week, we have one of the employees spend several hours mowing the grass, pulling weeds, cleaning the props, raking leaves, touching up paint, and doing anything else necessary to keep the appearance of the park in A1 shape. Remember that every client sees the park for the very first time the day of their session. You always want to make the right first impression with each of these students. A well-manicured park will give these teens added confidence in your studio and the portraits you will create for them.

Last, don't forget to market the fact that you have your own park setting. Most of the competing studios in my local area do not have a park on their property or have very limited outdoor capabilities. Many photographers will travel with the students to a local park for outdoor portraits. This is both time consuming and inconvenient. We emphasize this fact when a student calls us and when we send out promotional pieces. The piece on the previous page emphasizes the benefits of utilizing our portrait park.

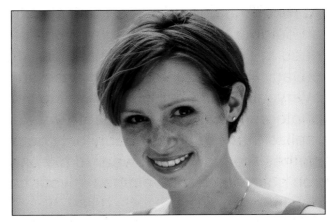

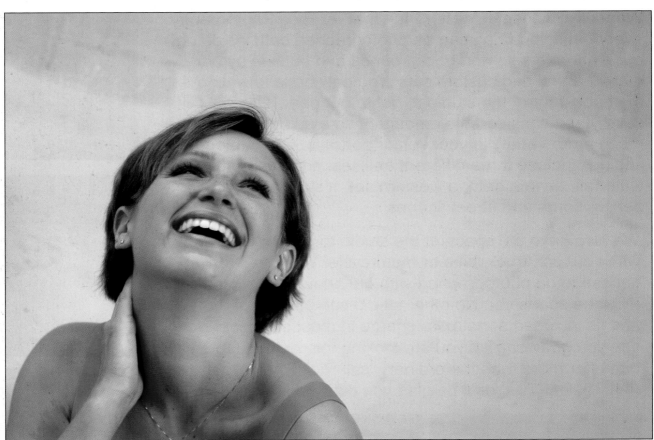

Photographer Lisa Smith created these signature outdoor images with an inexpensive lens called a Lensbaby, a device described by its manufacturer as a "flexible camera lens that creates a 'sweet spot' area of focus surrounded by a graduated blur that photographers can move around the image by bending the flexible lens tubing. Visit www.lensbabies.com for more information on this product.

Artistic Techniques for Increased Sales

Seniors crave variety, and they want images that capture their personalities. Digital imaging allows us to cater to this need and increases sales from these discerning clients.

In this chapter, we'll highlight some step-by-step imaging effects that can help you create some of the looks that are most popular with high school seniors.

⭕ PRO TIPS: BLACK & WHITE IMAGES WITH PHOTOSHOP

Converting Images to Black & White

by Michelle Perkins

When you print a color negative on black & white paper, you'll usually notice an objectionable loss of contrast. This can be bumped up using a higher-contrast paper (or contrast filters with multi-contrast paper). Much the same thing will happen if you convert a color image to grayscale in Photoshop using the Image>Mode> Grayscale command. Using this command will cause Photoshop to mix all of the original color channels into the one monochrome channel."

Color Correction. Fortunately, even if the Grayscale color mode is the "final destination" of your image, there are some things that you can do to make the transition as smooth as possible.

With any conversion to black & white, you'll have the best results if the image is good to begin with—accurately color balanced, with good contrast and detail in the highlights and shadows. It may seem odd that color correction would come into play when creating black & white images, but it's an important step.

Image Selection. You'll be happiest when you select photos to "transform" that have a strong design and don't rely primarily on color for their impact. Obviously, this is not always possible (you may have a color photo that looks better in color but must be used in a black & white newspaper). In this event, using the techniques described will be especially important for creating the best possible results.

Black & White Images in Color Modes. Don't overlook the possibility of presenting your black & white image in a color mode. For images to be used on the Internet (whether on a web page or as e-mail attachments), using the RGB Color mode is best. For process printing, you can use a grayscale image—but why? Using the four inks available in the CMYK process will provide richer, more pleasing results.

Converting Directly to Grayscale. Once you have color corrected your image and have achieved a good tonal range and contrast,

(see image 1, below) you are ready to convert the image to black & white. Using this method, your final product will be an image in the Grayscale mode—just what you'll need for creating marketing pieces like black & white newspapers, press releases, and newspaper ads that rely on single-ink printing.

1. Go to Image>Mode>Grayscale to make the initial conversion (image 2). The results should be quite good, but you should still take the time to evaluate whether some small adjustments could improve the results.

2. Start evaluating the image by looking at the Levels. Image 2 and the associated histogram (image 3) look pretty good. The histogram extends just about from edge to edge in the window, indicating that the image contains a full range of tones (from white to black).

3. However, without the colors, the image still looks a little gloomy. Brightening the midtones will frequently help the appearance of a black & white photograph. You can do this while you have the Levels dialog box open by simply moving the center slider (the gray triangle) slightly to the left.

4. Depending on your taste, you may still want to bump up the contrast a bit. You can do this in a

few ways, with varying degrees of control. The easiest way is to go to Image>Adjustments> Brightness/Contrast. By dragging the contrast slider to the right, you can increase the contrast. However, the contrast function applies an identical change to every pixel in the image (if you set it to +10, that change will be applied universally to the shadows, highlights, and midtones). This doesn't give you much control. (See images 4 and 5.)

5. A better way to adjust contrast is to use the Curves feature, where you can be much more specific about where and how you build contrast. To begin, open the Curves dialog box by going to Image>Adjustments>Curves. You'll now notice that, instead of multiple channels, the image has only one channel—gray. (See images 6 and 7.)

6. If you are happy with the midtones in the image (the middle grays don't look too dark or too light), you can nail these down by placing a point in the center of the Curves line without moving it up or down. (As you make your changes to the contrast, you can always adjust this, but it's a good place to start.)

7. To increase the contrast in the image, click on the line about halfway between the midtone and

*Left—Image 1. Original image by Patrick Rice. **Center**—Image 2. **Right**—Image 3.*

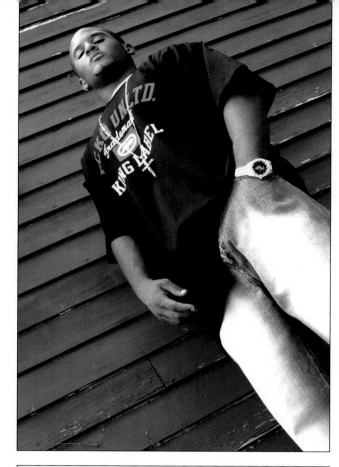

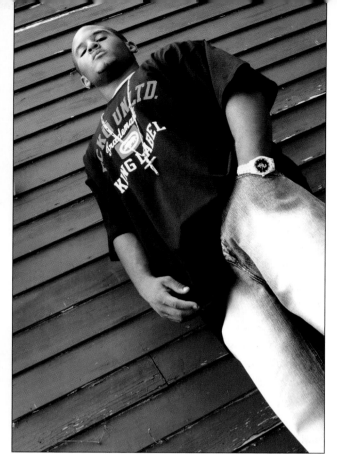

Top—Image 4. **Above—***Image 5.*

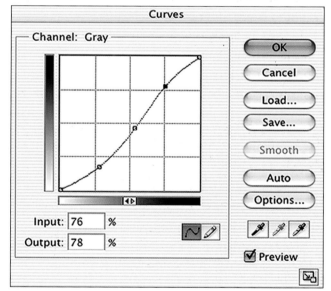

Top—Image 6. **Above—***Image 7.*

white point and pull down slightly. You'll see that the midpoint stays in place, while lighter tones become lighter and the darker tones become darker (use the gradient bar at the left of the grid as your guide). This yields an increase in contrast. (If you want to reduce contrast for some reason, you can do just the opposite, making darker tones lighter and the lighter tones darker.)

In image 6, you can see the results of applying the curve shown in image 7. The contrast is much better. When applying Curves to improve contrast, try to keep the curve itself as smooth as possible to achieve the most natural results. You can add as many points as you like, but usually two or three will be all that are needed. Also, keep an eye on the brightest highlights and darkest shadows to ensure that detail is not lost in these areas.

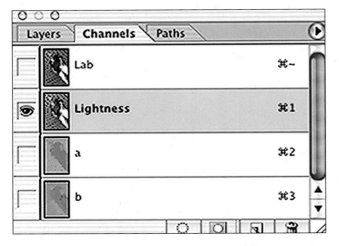

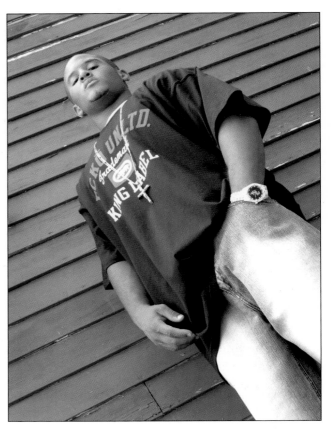

Above—Image 8. ***Top Right—****Image 9.* ***Bottom Right—****Image 10.*

Conversion Using the Lab Color Mode. Converting a color image to black & white using this method produces a crisp image with very little grain and deep blacks.

1. Open an RGB image. If there are any layers in the image, flatten them.
2. Go to Image>Mode>Lab Color.
3. In the Channels palette (Window>Channels), click on the Lightness channel to change your image to black & white. (See image 7.)
4. Drag the "a" channel into the trash can at the bottom of the palette (leaving this in place isn't a problem, but it will create an unneeded alpha channel).
5. Go to Image>Mode>Grayscale, then Image>Mode>RGB Color. (You cannot convert directly to RGB Color from Lab Color.)
6. If you like, you can still review the histogram in the Levels dialog box to ensure the tones are represented in the best way possible.

Conversion Using the Desaturation Method. Going to Image>Adjustments>Desaturate is a quick way to convert a color image to black & white. However, it results in slightly more grain than the Lab Color method and produces slightly flatter results. It's still a useful operation, since you can apply the change to a layer (unlike with the Lab Color method). (See image 9.)

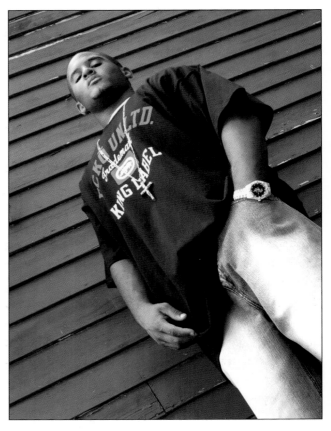

Desaturation Using the Channel Mixer Method

by Jeff and Kathleen Hawkins

Jeff and Kathleen Hawkins, who are renowned both for their outstanding images and their top-notch customer service, favor this technique when creating color to black & white conversions.

1. Open your image in Photoshop.
2. Go to Image>Adjustments>Channel Mixer.
3. Place a checkmark in the box labeled Monochrome. You can then accept the image as is, or adjust it.
4. If you wish to adjust your image, manipulate the sliders. To maintain the original brightness and contrast, the values of the sliders must total 100% (for example, if the red slider is set to +70% and the blue slider is at +0%, then the green slider should be set to +30%).
5. When you are happy with the image, click OK.
6. Save and close the image.

○ THE B/W CONVERSION FILTER

Another way to convert color files to black & white is to use one of the many third-party Photoshop plug-in filters that are available. One of my personal favorites, the B/W Conversion filter, is available in the Photo Design bundle from nik multimedia. This versatile filter loads easily into any of the more recent versions of Adobe Photoshop and can save photographers considerable time while still allowing creative control, all for under $100. This filter creates a black & white conversion using color filters similar to "conventional" photography. An image preview feature shows each change that is made in the dialog box as the effects are applied. Adjustments are made to the image using three slider controls: Brightness, Filter Strength, and Spectrum. As the name implies, the Brightness slider allows the photographer to make small or large adjustments to the brightness level of the converted black & white image. This

adjustment is necessary when the chosen filter darkens the image too much. The Filter Strength slider defines the degree to which the filter will affect the final black & white image. The Spectrum slider defines the color of the filter you are using with the black & white conversion. As in conventional black & white photography, using a color filter changes how objects in the scene appear. The entire color spectrum is available with this filter, so you can customize your results to achieve the very best image.

When creating color images for conversion to black & white, you must be astutely aware of the colors in your subject and background. Many colors are recorded as gray in black & white. This could cause a loss of separation between the subject and background.

For more information on plug-ins, see pages 87–88.

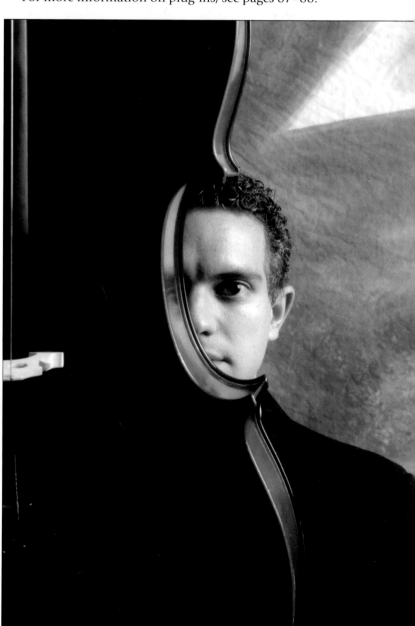

For the best results, capture your digital images in color then use your software to convert the image to black & white. Image by Ken Holida.

Digital toning allows you to create subtle or intense toning effects. Image by Mark Bohland.

○ TONING PHOTOGRAPHS

Sepia toning by traditional means produced beautiful images, but the process was anything but pleasant. I don't think I'll ever be able to permanently erase the memory of the rotten-egg smell of the chemicals. This alone would prevent me from doing any traditional sepia toning or offering it to my clients. In fact, I experimented with other ways of achieving a brown tone in a black & white print. Taking advantage of the fact that most consumers can't tell the difference between a true sepia-tone print and any other print with a brown cast to it, I typically made a boiling-hot pot of strong black coffee and filled a print tray with it. I then dropped my black & white images into the liquid and stained the entire print brown. Although I was able to get away with "cheating," I always knew that the images never truly looked like real sepia prints. The digital darkroom has changed all of this.

Photoshop allows you to use a sepia action, which is accessed via the actions palette, the Hue/Saturation feature, or a Photo Filter Adjustment Layer (Photoshop CS). With any of these techniques, sepia toning is both fast and efficient, and I believe the artistic

digital black & white printmaker has even more creative control than he ever had in the past.

In our high-school senior business, we have begun creating color-toned images for many of our clients. In many of today's fashion magazines, you will see images that are monotoned with a single "extreme" color. These striking and unusual photographs immediately grab your attention. I create this look by using my digital darkroom—Photoshop.

To begin, I open my black & white image in Photoshop, then go to Image>Adjustments>Curves. (You can save time in Photoshop by using the shortcut keystrokes for this function—ctrl-M [or cmd-M for Macs]). The default Channel setting is RGB (which stands for red, green, and blue). By clicking on the arrow to the right of the Channels field, you can access each of the three sub-channels separately. By selecting the Red channel, for example, you can make adjustments to that individual channel. With the Red channel selected, you will achieve a red-toned image by pulling up on the curve; when the curve is bent downward, a cyan hue will be achieved. The degree to which the toning is applied is controlled by the amount that the curve is altered. As you play with the effect, be sure to check the Preview window to ensure that you're getting the desired look.

Dramatically toned images are very striking and are popular with today's seniors; they like the look, want to make a statement with their pictures, and want their photos to be unique. This toning technique allows us to give these clients an unusual product without having to shoot any differently—it's all done post-capture.

○ PRO TIPS: SEPIA TONING

Photoshop: The Hue/Saturation Method
by Michelle Perkins

1. Begin with a digital image in the RGB Color mode (image 1).
2. Open the Hue/Saturation dialog box (Image> Adjustments>Hue/Saturation). Click on the Colorize box and be sure to activate the Preview box as well (image 2).

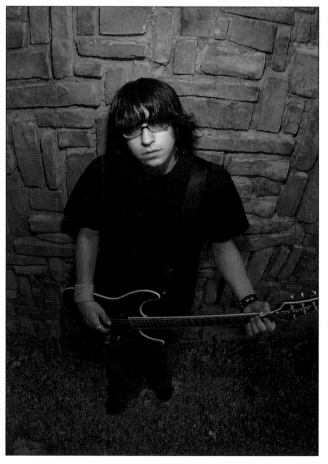

Top Left—Image 1. Original image by Patrick Rice. Bottom Left—Image 2. Hue/Saturation dialog box. Top Right—Image 3. Bottom Right—Image 4.

3. Adjust the sliders to create whatever color (hue) and intensity of color (saturation) you like. Adjusting the lightness slider will adjust the overall lightness of the image, which you can also do as you see fit. For the sepia example (image 3), the hue was set to 23 and the saturation to 18. Adding a blue cast (image 4) creates another nice look. To do this, follow steps 1 and 2 above, but set the sliders to hue=223, saturation=20, and lightness=0.

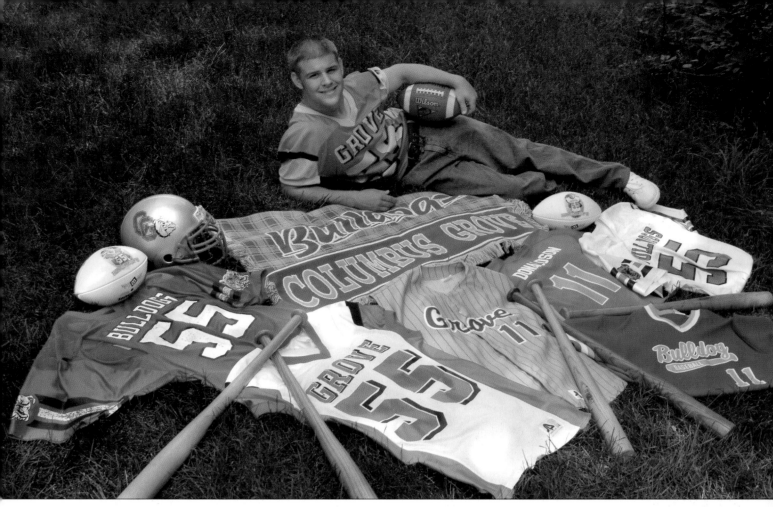

With Photoshop, you can produce a wide variety of image enhancements from traditional to extraordinary. Top image by Michael Ayers. Above image by Robert Kunesh. Right-hand image by Bernard Gratz.

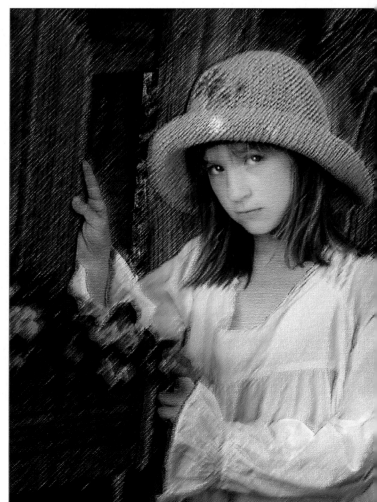

○ DIGITAL HANDCOLORING ADVANTAGES

With traditional handcoloring, it was sometimes difficult to accurately re-create the color that appeared in the original photograph. The areas of the photograph that could be changed were limited; the dark-gray areas of a black & white image could not be colored easily—the color would barely show through, if at all. For this reason, our studio and other photographers across the country began showing black & white infrared film images with some selective color. In an image captured with infrared film, the usually dark-green trees and grass would reproduce light gray or white, tones that allowed photographers to selectively add a green hue.

With digital black & white photography, the process of adding subtle or vibrant color to any area of a black & white image has never been easier. For those of you who never got the hang of coloring, you can create selections or masks to help you stay inside the lines. You can also try out lots of different looks and experiment freely with colors before deciding what works best. Remember—if you goof or change your mind, you can just hit Edit>Undo (or use the History palette to backtrack if you didn't notice the problem right away).

Like most tasks, handcoloring in Photoshop can be accomplished in several ways. The following are two common methods.

Selective handcoloring can help you create a teen or senior image that will wow your client. Image by Mark Bohland.

○ PRO TIPS: HANDCOLORING STRATEGIES

Techniques for Handcolored Portraits

by Michelle Perkins

Handcoloring your images can be done quickly and easily in Photoshop.

Handcoloring with Color Layers. This method allows you to control the degree of color you add to your image.

1. Begin with an image in the RGB Color mode (Image>Mode>RGB Color). The image must be in a color mode or you will not be able to add color to it. If you want to add handcolored effects to the color image, proceed to step 2. For the more traditional look of handcoloring on black & white, go to Image>Adjustments> Desaturate to create a black & white image in the RGB Color mode. (See image 1.)

2. Create a new layer (Layer>New>Layer) and set it to the Color mode using the pull-down menu at the top of the Layers palette. (See image 2.)

3. Double click on the foreground color swatch to activate the Color Picker. Select the color you want and hit OK to select it as the new foreground color. This is the color your painting tools will apply. You may switch it as often as you like. (See image 3.)

4. With your color selected, return to the new layer you created in your image. Click on this layer in the Layers palette to activate it, and make sure that it is set to the Color mode.

5. Select the Brush tool and whatever size/hardness brush you like, and begin painting. Because you have set the layer mode to color, the color you apply with the brush will allow the detail of the underlying photo to show through.

6. If you're a little sloppy, use the Eraser tool (set to 100% in the Options menu) to remove the color from anywhere you didn't mean to put it. Using

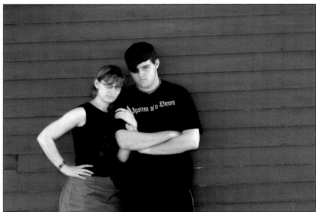

*Top Left—Image 1. The color image is desaturated. Image by Barbara Rice. **Bottom Left**—Image 2. **Top Right**—Image 3. **Bottom Right**— Image 4. The final image.*

the Zoom tool to move in tight on these areas will help you work as precisely as possible.

7. If you want to add more than one color, you may wish to use more than one layer, all set to the Color mode.

8. When you've completed your "handcoloring," the image may be either completely or partially colored. With everything done, you can flatten the image and save it as you like. (See image 4, facing page.)

Desaturating with Layers. Here's a quick way to add a handcolored look in seconds—or, with a little refinement, to avoid having to select colors to hand-color with. This technique works only if you are starting with a color image.

1. Begin with a color image in the RGB Color or CMYK Color mode.
2. Duplicate the Background layer by dragging it onto the duplication icon at the bottom of the Layers palette. (See image 1.)

3. Desaturate the background copy by going to Image>Adjustments>Desaturate. The image will turn black & white—but by reducing the opacity of the desaturated layer you can allow the colors from the underlying photo to show through as much or as little as you like. (Image 2 was set to 70% opacity; image 3 was set to 50% opacity.)

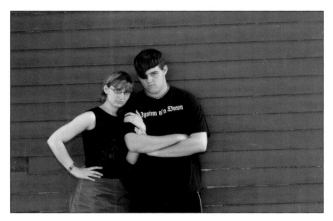

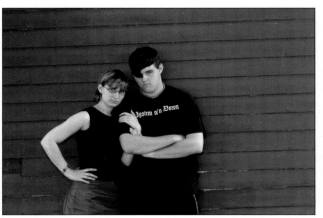

Top—Image 1. *Bottom Left*—Image 2. *Top Right*—Image 3. *Center Right*—Image 4. *Bottom Right*—Image 5.

4. To create the look of a black & white hand-colored image, set the opacity of the desaturated layer to 100% and use the Eraser tool to reveal the underlying photo. Adjust the opacity of the Eraser to allow as much color to show through as you like. (See image 4, previous page.)

5. If you make a mistake and erase an area you meant to leave black & white, you can use the History Brush to paint the black & white back on from the desaturated history state.

6. For a very soft, desaturated look, set the opacity of the desaturated layer to about 80% (just enough to let colors show through faintly) and use the Eraser tool (set to about 50%) to erase areas where you want an accent of stronger color to appear. (See image 5, previous page.)

○ DIGITAL INFRARED SENIOR PORTRAITS

Infrared photography lends itself well to landscape images. Besides the military, medical, and scientific applications of infrared, scenic photographers have been the most prolific users of this medium. In more recent years, many photographers, including myself, my wife Barbara, and my stepson Travis Hill, have utilized infrared successfully in the weddings we photographed. This success led to our joint book project, *Infrared Wedding Photography*, published by Amherst Media (2000).

While infrared film was expensive and had to be handled with the utmost care, digital infrared imaging has put this art form within the reach of every photographer. These images are captured using an opaque filter on the digital camera's lens (and in some cases, by having your repair shop make a simple camera modification)—and the clients can see the results instantly. (For more information on all aspects of digital infrared imaging, please see my book *Digital Infrared Imaging* [Amherst Media, 2004].)

Our studio began creating outdoor infrared images of high school seniors a number of years ago with great success. The students appreciated how dif-

Infrared renders skin tones beautifully. Image by Patrick Rice.

ferent the surroundings appear in infrared and found the images intriguing.

In the studio, we don't have chlorophyll-rich grass and trees to glow white in our infrared images. So, the question becomes "Why bother shooting infrared in the studio?" The answer is actually quite simple: the results in the studio are beautiful but are not the same as those usually achieved outdoors.

In fact, the key to the difference is not the infrared medium but how the photographer records his image. When capturing scenic infrared images, photographers generally use wide-angle lenses. When using a longer lens to better capture the student's features, the magic happens. Infrared imaging gives a porcelain-like appearance to the skin. Redness and other skin discoloration disappear without any manipulation by the photographer. The result is an image that resembles George Hurrell's 1930s Hollywood glamour photographs. Hurrell was said to make stars of his day look "godlike." He accomplished this task by heavy retouching of the 8 x 10-inch negatives that his view camera produced. With digital infrared, the photographer can achieve the same look without the work or expense.

A word of caution when creating infrared portraits: as discussed in *Digital Infrared Photography*, in

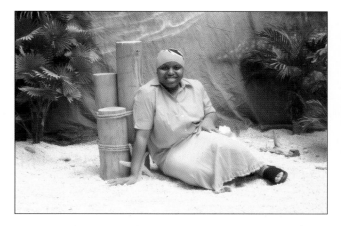

*Top Left—The nik multimedia Sunshine filter adds punch to a flat, low-contrast image. **Bottom Left**—This portrait was enhanced using nik multimedia's Monday Morning filter. **Above**—This photo was made using the nik multimedia Midnight filter. Images by Patrick Rice.*

○ ARTISTIC EFFECTS PLUG-INS

Among the many new technological innovations we've discovered, plug-in filters are one of the most exciting. These small accessory programs can be installed on your computer to add new and exciting effects to those that already exist in Photoshop. In our studio, we have absolutely fallen in love with nik multimedia's easy-to-use plug-ins, and we utilize them often to create a number of interesting effects in our images.

Monday Morning from nik multimedia's Color Efex! line is a studio favorite. This filter creates a soft and very moody rendition of the image and allows you to fine-tune the results if necessary. The Pastel filter replicates the traditional look of pastel artwork with amazing accuracy. The Sunshine filter can add

some images, a client's dark-blue eyes may appear to "drop out" and record very dark or even black. To prevent this, have the client look downward or to either side, away from the lens.

A simulated infrared look can also be created in Photoshop. Please see the above-mentioned book for step-by-step instructions on creating this look.

punch to a flat, low-contrast image. These are just a few of the many filters that are included with each plug-in set. I am sure that each photographer will discover different ways to use these plug-ins to enhance their photography.

Plug-ins also have something to offer photographers who aren't head-over-heels about special effects and have little time to mess around with step-by-step applications. We've tested countless methods of converting a color image to black & white. We have found nik multimedia's B/W Conversion filter (see page 77) equal to or superior to all of them and now use it exclusively. In most cases, the software makes a perfect calculation regarding the extent to which everything should be adjusted.

○ COREL PAINTER

Iowa photographer Craig Kienast was looking for an outlet that would allow him to be truly creative with his senior portraits when he discovered the possibilities that Corel Painter provides. His work is like none I've ever seen. After attending one of his day-long seminars, I was sold on using his techniques for my senior portraits.

Craig is very proficient in Adobe Photoshop, and he does much of the work on his Fantasia art prints in this program. First, he does a thorough job of cleaning up the student's complexion and enhances the eyes in Photoshop. He then brings the file into Corel Painter and uses the Smear tool (which is found in Painter's Blenders modes) to distort the background or other elements in the image. The Smear tool can add motion or a brush-stroke look to the areas to which it is applied.

The great thing about creating these prints is that they do not demand a lot of skill in either Photo-

Above and Facing Page—These Fantasia photos were created using the tools available in Photoshop and Painter. Images by Barbara Rice.

shop or Painter. With the right scene and pose (typically something a little more dramatic), you can transform ordinary photos into something very artistic.

At Rice Photography, we do most of these images on speculation and show them to the students and their parents when they pick up their proofs or view their images at our studio.

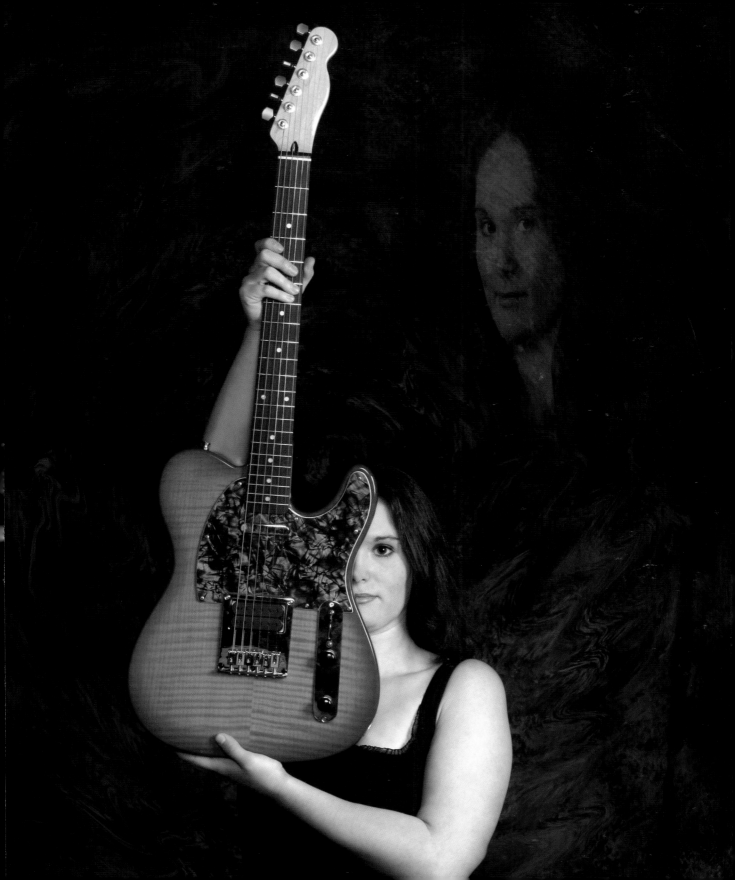

Smart Marketing

In high-school senior photography, marketing is more important than photographic talent. All the skill and all of the props and sets in the world will not make you successful without a solid marketing program that attracts today's high school seniors.

Our studio does not use newspaper, radio, or television advertising for any of our photography services. We have a single-line listing in the telephone book. We rely mainly on mailers, our student reps (also called ambassadors, but we call them "models"; see pages 102–5), and word of mouth, because they work. We supplement these strategies with mall displays twice a year, in February and September. These displays contain both senior and wedding images and are scheduled to correspond with scheduled bridal shows, which are held at a mall located a couple of miles down the street from the studio.

◉ MAILERS

General Mailers. As mentioned above, we rely heavily on mailers in order to get the word out about our studio. We send out our first

Facing Page—Word of mouth is one of the most powerful forms of advertising. Photos like this one make for great referrals! Image by Leonard Hill. Above—Be sure to update your mailers regularly for maximum impact. Postcard by Rice Photography.

mailing in February to recruit our senior representatives. General mailings to prospective high school seniors begin in April and continue as often as once a month through September. While many of these mailings inform students about our current promotions, we also send others that promote particular sets or props that other photographers do not have.

The months of June, July, and August are the busiest for photographing seniors, as any photographer can attest. We run specials that are more substantial early in the season and diminish as the season wears on. This ensures that we can photograph as many seniors as possible before summer vacation begins.

It is important to update your mailers each year with fresh images that are representative of the work your studio produces. High school seniors are a discriminating market. Be sure to showcase the type of images that cater to their needs.

Custom Mailers. When we receive a list of names from our models, we create custom mailings for that particular school. We also send out targeted marketing pieces that are personally addressed to seniors of a specific school. Our models generate these names for us. These lists are much more accurate than those purchased from national mailing list companies. Although these teens are receiving countless mass-

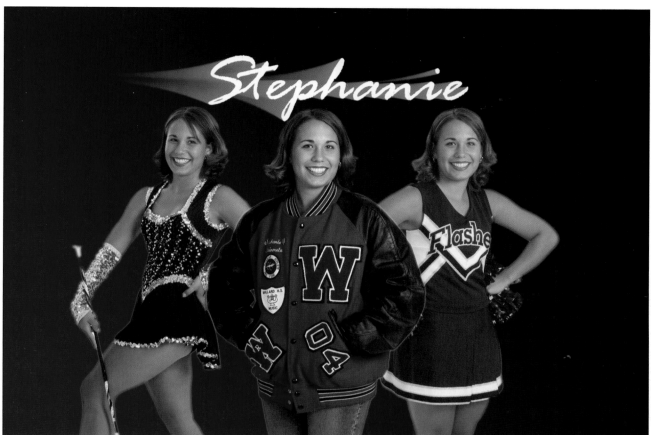

Facing Page—Image by Scott Gloger. **Above—***This type of image celebrates a student's varied interests. Image by Ken Holida.* **Right—***Promotional mailer by Rice Photography.*

mailings, we have added a personal touch that helps our studio stand out.

Examples of the various general and targeted mailers we use appear below.

Saint Edwards High School Class of 20XX

Saint Edwards High School is one of the finest schools in the Greater Cleveland area. For years, its graduates have gone on to be leaders in the fields of business, law, medicine, sports, and numerous other professions. It is no ordinary high school, and you deserve more than just ordinary high-school senior portraits! Your senior portrait can make a statement about who you are and what activities you are involved in. No longer do you have to settle for the same old "snapshot" that so many photography studios produce. At Rice Photography, we will work with you to create the ultimate portrait experience.

Unlike the huge contract photography studios, we will take the time to create memorable portraits that you will always be proud to have and display.

We would like to extend an offer of 50 percent off our deluxe session. Simply mention this letter when you call us at 440-979-0770. We are so confident that you will love your portraits that we

Image by Leonard Hill.

St. Edwards High School Class of 2005

You don't have to settle for ordinary high-school senior portraits. At Rice Photography, we will take the time to create timeless photographs that reflect your unique personality. We do not have a huge staff of photographers with little or no experience. Patrick and Barbara Rice have been in professional photography for over twenty-five years. They have each received countless awards for their photographic artistry and each has two masters degrees in photography.

At Rice Photography, we take full advantage of the latest digital technology. Your photographs can be viewed immediately after your session on our professionally color-calibrated monitor. We can also post your photographs to a password-protected website so that distant relatives can enjoy your portraits. Of course, we can still produce 4 x 5-inch paper proofs of each of your portraits—not multiple-image proof sheets where the photos are too small to view easily. With digital imaging, your photographs can be color, black & white, sepia-toned, or spot colored—all at no additional charge!

July Special—Sitting Fee Only $10

Call any time during the month of July to schedule your high-school senior portrait with Rice Photography and receive our deluxe indoor-and-outdoor senior session for only $10. That's a savings of $70 off our regular prices!

Your senior portrait session can be scheduled for any time between July and November, but you must call us now at 440-979-0770 to reserve a time. Hurry, Rice Photography chooses to only photograph about one hundred select high school seniors each year, and sessions are filling up fast. Don't miss out on this great opportunity to enjoy huge savings and get great senior portraits!

guarantee it! If you aren't satisfied with your photos, we will be happy to do them again. If you are still not happy, we will give you all of your money back, plus an additional $5.00 for your trouble. You can't go wrong! Give us a call today to schedule your senior portrait session. You'll be glad you did!

When sending out our summer specials mailers, we often include a letter that mentions our considerable photographic experience and the fact that we are award-winning photographers with masters degrees in photography. This letter also outlines the advantages of digital technology and the many choices that digital imaging affords the students. Most of our offers run for a particular month, and the discounts diminish as the senior season progresses.

The following letter was sent to an area school that is not that close to our studio. We know students have many options when it comes to selecting a photographer, and in this case, we are not the most convenient choice. This letter gives the students from this

school solid reasons to drive another twenty minutes out of their way to use us for their senior photography. The testimony from a member of these students' graduating class further substantiates our claims.

It's Worth Some Extra Time to Get What You Really Want

Dear Valley Forge Senior,

Not everything we want in life is extremely convenient; thus, we tend to be willing to travel to shop for many products and services that we desire. Sometimes the business just down the street is the easiest to get to, but it doesn't have everything that you are looking for. If this were not the case, you would never drive as far as South Park Mall or Great Northern Mall when you have Parmatown Mall in your neighborhood. Many times, it is worth the extra twenty minutes' drive to get what you really want.

Your high-school senior portraits are no different. Sure, there are photography studios right there in Parma. Sure, these studios are very convenient, but will you truly get what you want? At Rice Photography, we pride ourselves in being different from other photo studios. We offer more backgrounds, more props, and an entire outdoor portrait park just to ensure that you will get the very best senior por-

traits. Yes, we are less convenient and it will take longer to get to our studio, but isn't an extra twenty minutes worth it to ensure memorable senior portraits? Won't a little extra time be worth it when you can be truly proud of your photos? Don't you want more than just the same, tired old pictures that the contract photographers take?

Just read what one of your classmates had to say about his senior portraits from Rice Photography:

"The pictures that I had taken at Rice Photography were some of the best that I have ever seen. The care you took with my photographic experience was extraordinary! Thank you!"

—Adam Kronenberger

Spend a little more time to get the very best in senior portrait photography. Call Rice Photography today at 440-979-0770. You'll be glad you did!

Sincerely,
Barbara and Patrick Rice

Unlike some studios, we do not send clients e-mail except to respond to questions that they have raised. This typically happens after a prospective client has logged on to our website and wants further information.

Left—Image by Patrick Rice. **Right—***Promotional material by Rice Photography.*

○ THE INTRODUCTORY LETTER

One of the first mailings that you send out to high school seniors and their parents should include an introductory letter. This idea has been used by studios across the nation, thanks to photographers like John Hartman. The introductory letter lets the seniors and their parents know who you are, where you are located, and why they should choose your studio for their portraits. This letter sets the stage for all of the follow-up mailings that you will send out throughout the year. Many studios send this letter along with a special offer or a color postcard featuring samples of their work. This letter should urge the seniors to commit to having their portraits taken early in the season. By creating a sense of urgency, we can motivate some of the students to get their portraits taken in April and May, before the rush months of June, July, and August. The letter also outlines our money-back guarantee. This gives both the senior

and their parents some peace of mind in choosing our studio.

Senior Class of 20XX—Thank You for Considering Rice Photography as Your Senior Portrait Photographer!

My name is Barbara Rice. I along with my husband Patrick (and our associates Fallon, Travis, Tony, Chad, and Rick) run Rice Photography. Our studio is conveniently located on Lorain Road in North Olmsted, right off of Interstate 480.

We are ready to go out of our way to make you happy.

SENIOR PORTRAITS ALREADY! WHY SO EARLY?
Actually, there are several reasons why it's time to take care of your senior portrait appointment right now. Each year, the number of students increases considerably in the surrounding areas. We photograph students from as far south as Independence, as

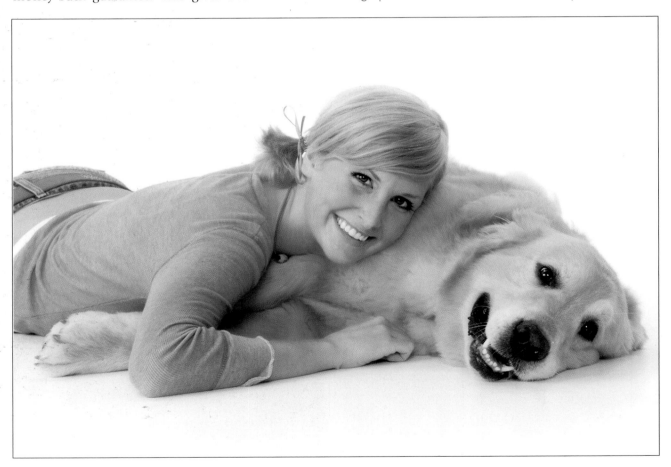

Pets make for great senior portrait companions and are a natural addition to the image. Image by Leonard Hill.

far north as Bay Village, as far west as Valley City, and as far east as Solon. From this area, there will be over 10,000 high school seniors in the class of 20XX.

Not only are there more students, but, nowadays, we spend more time photographing each senior. Therefore, we only have about 500 available appointment times, so that means we could at best only photograph 5 percent of all of these seniors. We fill our available appointment times on a first come, first serve basis. As of the writing of this letter, we are already reserving senior appointment dates and times. This means that we are already filling up into the summer months, so scheduling your appointment needs to be done now.

I want you to know that we're going to save you money, too. For 20XX seniors, we're having a sale on our most popular session—our deluxe session. If you call and schedule your deluxe session, you'll receive half off the session fee. This special ends when all available times are filled.

At Rice Photography, we don't try to sell you packages full of things you don't want. You purchase only the sizes and quantities you want, with no minimum order—that's right, no minimum order!

Sincerely,
Barbara and Patrick Rice

Another variation of the senior letter that we have used appears below. It is kept light and upbeat, focusing primarily on making the senior comfortable with choosing our studio for their portraits. This letter also includes information on our money-back guarantee.

Here's Why Rice Photography Should Be Your Choice

Countless high school seniors from this year's graduating class have already secured an appointment for their senior portrait session at Rice Photography. These students knew that Rice Photography has a reputation for great service and exceptional quality and were quick to call. There are even more, like yourself, who have not reserved their appointment yet and are trying to secure one of the last few available sessions. Rice Photography remains the premier senior portrait studio for the student who wants variety, creativity, and, most of all, individuality in their photographs. Here is why high school seniors are choosing Rice Photography over other studios:

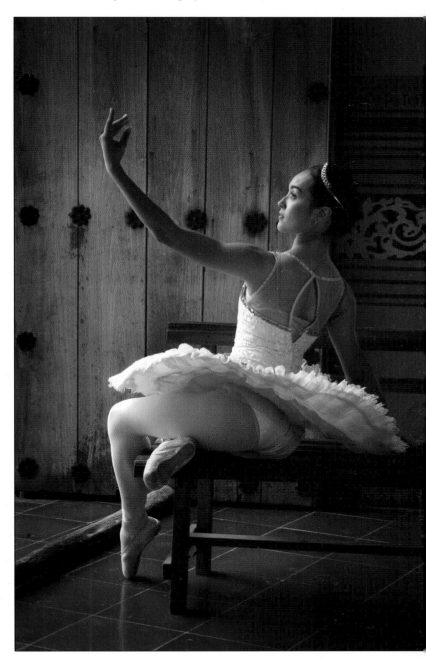

Image by Monte Zucker.

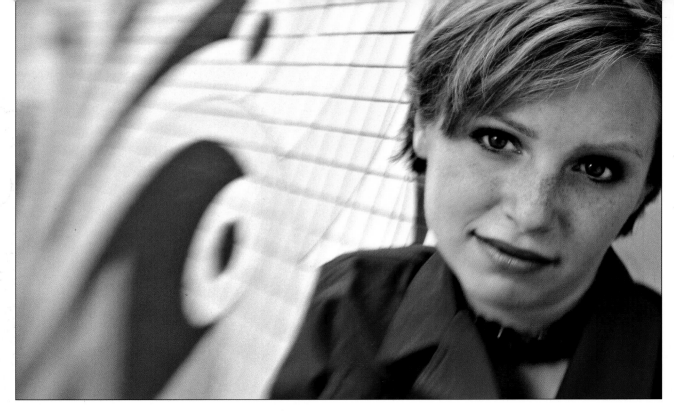

These vibrant images are dynamic and fresh and are filled with attitude. Images by Lisa Smith.

IT'S ALL ABOUT YOU!

The emphasis is on you at Rice Photography. We want your senior session to be a fun experience that you will enjoy and remember!

YOU'LL LOOK FABULOUS!

Most people don't think they take a good picture. Well, at Rice Photography, you will! We'll work with you to help choose the right backgrounds and props for your outfits and for your personality. This ensures that you will look your very best in every picture!

YOUR SATISFACTION IS GUARANTEED!

Aren't you wondering, "What if they don't turn out?" Well, not to worry. At Rice Photography, we have a money-back guarantee!

If, for any reason, you are unhappy with your original proofs, just tell us, and we will make additional poses to your liking, at no cost to you. If you're still not satisfied, we will refund all of your money plus an additional $5.00 for your trouble. Check the competition; this is the best guarantee of its kind in the industry! How can you go wrong?

○ MAXIMIZING THE INTERNET

Today, you can't make it in the business of teen and high-school senior photography without having an Internet presence. First, photographers must remember that to their potential clients (teenagers), the Internet has always existed. It seems like everyone of this generation has a computer and some type of Internet access. They no longer ask if photographers

have a website, they *expect* that you do business on the web. These seniors want to be able to shop different studios like they shop for other products and services. The Internet saves them time and helps them to make an informed decision.

We have had a studio website for over ten years, and it has been revised several times since its inception. This is probably the biggest problem that I see with most photographers. They create a website for their business, but they never update it. We wouldn't think of showing the same samples over and over, year after year. We wouldn't consider using the exact same mailer for five or six years running. Why would we allow a studio website to remain unchanged for extended periods of time?

In addition to using our website as a tool to help us book more senior photo sessions, we use it as an alternative to more traditional proofing for many of our students. We utilize a web company called eventpix.com to host our senior portrait images and provide a means for the students and their families to order images online. This service is very affordable and easy to use. For only $6.95, a photographer can post up to fifty images from a session for up to sixty days! Each of the photos from the session are all password-protected, and the studio can choose to watermark each image to discourage unauthorized printing of any portrait. To make this option work for our studio, we had business cards printed with the following information:

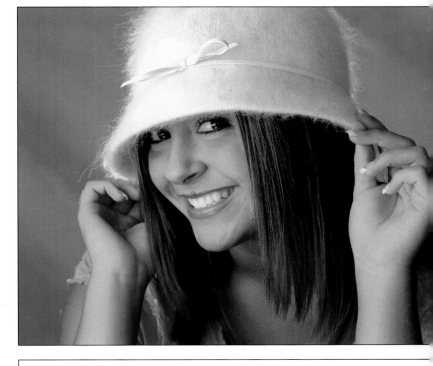

You can view and order images from your session at www.eventpix.com. Click on Guest, type in Rice Photography under Studio Name, and click on your name.

The password for your session is _____.

Note: If you find a particular image unflattering, please feel free to e-mail prfisheye@aol.com to have it removed.

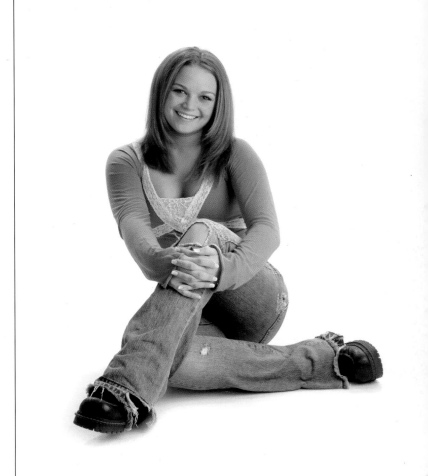

Images by Visualizations.

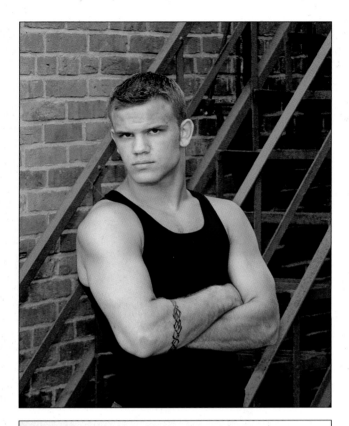

*Facing Page—A classic prop like this chair aids in posing and can enhance the appeal of the image. Image by Scott Gloger. **Top**—Image by Mark Bohland. **Above**—Promotional card by Rice Photography.*

We present the student with three or four of these simple cards so that they can distribute them to some of their relatives and friends. Of course, we have given them far more upon request. This has been an effective selling tool for both booking the session and completing orders.

Some studios allow students to schedule their sessions online. This is very efficient and allows the students to set up their senior session when they want.

O YEARBOOK CONFERENCE

Photographer Robert Williams has begun something he calls the Annual Yearbook Conference. Robert contacted the juniors on the yearbook staffs from the high schools in his area to offer an informative day of seminars to help them produce a better-quality yearbook for their school. Robert brought in a speaker from a yearbook company who offered some great design tips. In addition, Robert spoke on how to take better sports/action and candid images. The program was a great success, and he booked a senior portrait session for almost every junior who attended.

O LAST-CHANCE OFFER

Many studios have had great success with what is sometimes called a Last-Chance Senior Portrait Special. In the early months of the year, studios will send out a letter or postcard announcing this offer to the graduating senior class. In recent years, we have noticed that many high school seniors want their photographs taken as close to their actual graduation as possible. The reason given is simple—many feel that they look better later in their senior year. They may have changed their hairstyle or done something else to enhance their look. It may also be that their skin has cleared up from the previous summer when their first senior photographs were taken. Whatever the case, studios that are catering to this need are reaping significant financial rewards.

O SENIOR OPEN HOUSE

One of the most innovative marketing ideas for high-school senior photography is the senior open house. Photographer Robert Williams began this promotion in 2003 and immediately had incredible success. In early April, Robert printed promotional 6 x 9-inch cards with four-color images on one side and black text on a white background on the reverse. He invited the juniors to an early-May open house and promised a 75-percent discount off his deluxe senior portrait session—his most expensive session—as a bonus for attendees. His mailing list included approximately 3,500 names, and the response was overwhelming! He had over two hundred students

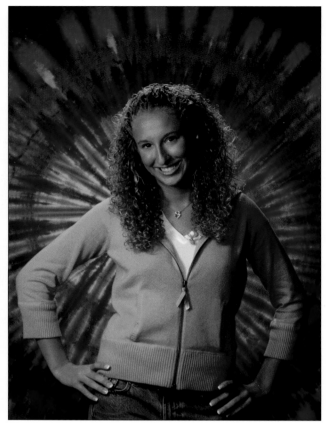

Left—A strong marketing program that showcases your unique image style is crucial for increasing your studio's profits. Image and mailers by Robert Williams. **Above**—*Image by James Williams.*

show up for his three-hour open house and booked over one hundred prepaid sessions on that day.

Robert knew he had a winner with this promotion and planned for success. He utilized both the front and back parking lots in the strip where his studio is located. He also received permission to utilize the parking areas of the businesses on both adjacent sides of the strip. He further prepared by hiring a police officer to direct traffic into the parking lots during the open house.

Once inside, the students were given a tour of the studio and were then taken to view the outdoor garden area. Many senior photographs were on display, reinforcing the popularity of Robert's unique props and sets. Food and soft drinks were available, and everyone was registered to win a free DVD player. The DVD player only cost Robert $75, but the prize held a great deal of interest for the students.

○ THE AMBASSADOR/MODEL PROGRAM

Many studios, ours included, have implemented what is often known as an ambassador or student representative program (we call our representatives "models") to get high school seniors to market their studio to their peers. This type of marketing capitalizes on the fact that referrals from past clients are one of the strongest forms of advertising.

In the beginning of March, Jim Williams mails a letter to juniors that outlines his ambassador program, which he calls the Great Model Search. Any student interested in participating in the program must respond by the end of the month and come in for a group meeting to fully understand the details of the program.

Jim's goal for this program is to book early senior sessions and tap into a new school's student body to build his business. Most studios will give each ambassador their senior session free of charge and allow them to take their image folio to show to their friends at school.

Some studios choose to have the ambassador leave a deposit when they take out their folio or senior album. Experience has taught us that you need to secure a deposit in case the model never comes back again. This way, you have received a sum of money equal to or greater than the value of the session fee and proofs.

Jim requires a $300 deposit before the model can take the folio out of the studio and begin to show it to his or her classmates. This point is crucial to the photographer. Many studios abandon their model programs after they give students free sessions, the student leaves with the folio, and they never hear from them again. Our studio has experienced this problem. Now, with a $250 deposit required to take out the photos, we have some financial reward for our efforts if we never hear from the student again. Because of this deposit, we collected $5,000 during one of the slowest months for senior photography!

Jim's program is different from that used by many other studios in that he awards his models with 25 cents per name and address they collect and a $25 bonus for bringing in the entire class list. This student-generated class list is crucial because it is highly accurate, unlike the lists purchased from a national list company. Jim told me that when he compared a class list gathered by a student to one purchased from a list company, he was astonished to learn that the company's list was only about 30–40 percent accurate! He was mailing to students who were sophomores and freshmen, or possibly had

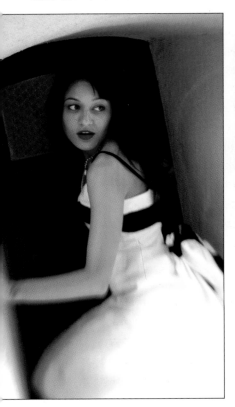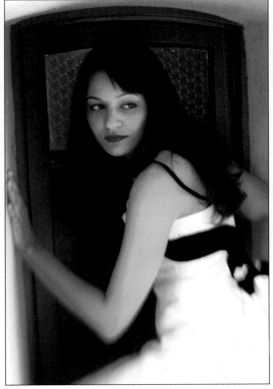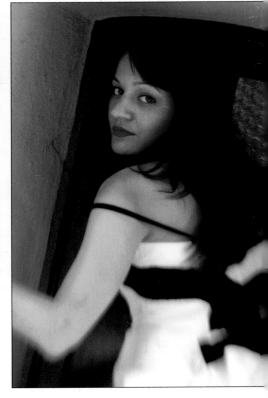

Utilizing student models is an effective marketing technique that promises great returns on a small investment. Images by Lisa Smith.

Top and Bottom Left—We use these mailers to spread the news about our model program. Top Right—We use this twelve-hour sale mailer to drum up business. Promotional materials by Rice Photography.

already graduated. On top of that, some of the names on the national company list were totally erroneous; no such person lived at the given address. Moreover, some students who should have been getting mailings were not on the national company's lists at all. Jim was completely ignoring some potential clients because of bad information.

With student-generated lists, we are no longer just sending out mailers and hoping to reach the right students. Instead, we take a more cost-effective, targeted approach that makes good use of our marketing budget.

My school lists have been comprised of as few as twenty-five names and as many as three hundred. Since the numbers for each school are relatively small, I can afford to send all of these mailers via first-class mail. This way, I know that our piece will reach the prospective client in one or two days—not the three days to three weeks that bulk mail can take to deliver.

We hand-address each envelope to add that special touch. Everyone receives so much junk mail these days, it is often hard to guarantee your letter gets opened at all. Everyone opens hand-addressed mail. In fact, studies have shown that most people will open hand-addressed letters first when going through their mail. This extra effort gives us a competitive advantage in the marketplace.

The students on these targeted mailing lists receive a mailing about once a month. I want them to be inundated with material from our studio. These mailings establish credibility and keep us ahead of the formidable competition in the western Cleveland suburbs.

Jim and I began this model search program about a week apart. The results? Both studios photographed twenty juniors during the month of April—which is about nineteen more than we would normally photograph during that month.

It's a good idea to create a standard form to enroll students as studio representatives. Robert Williams words his this way:

Robert Williams Studio Representative Application

Name _____ Phone _____

Address _____ School _____

City _____ State _____ Zip _____

Extracurricular school activities (offices held, clubs, sports, etc.) _____

Plans after graduation _____

Parent or guardian's name _____

Address if different _____

Are you willing to grant Robert Williams Studio permission to use your portraits in advertising?
❏ yes ❏ no

Our representative program is designed to promote goodwill and improve communications throughout the schools in the northern Ohio area. You will be a public relations representative. This will be a great opportunity to meet students from other schools and be involved in a professional program.

Thanks for your interest in becoming a representative. If your application is approved, you will be contacted regarding a representative meeting, which will provide you with all of the information about our program.

I, _____, realize that this program is geared to help promote Robert Williams Studio, and I will not accept a representative position from any other studio. I also realize that I am under no obligation to purchase photographs. Any violation of this agreement will terminate any commissions from referrals.

Applicant's signature _____

Parent's signature _____

Well-crafted forms and mailers will help your business to put its best foot forward. Postcard by Robert Williams.

○ THE TWELVE-HOUR SALE

In the Mideast, many senior photography studios use a promotion known as the twelve-hour sale. This promotion usually offers a drastic reduction on the session fees if the student calls in during the twelve hours and prepays for their session, which is held at a later date. The twelve-hour sale is targeted at those students who are cost conscious and looking for a great deal. Most studios (including ours) offer 50–75 percent off of the cost of any session. The sale takes place in April or May and helps to fill in sessions for later on in the summer. By getting the students to commit to our studio with a prepaid session fee, there are almost zero no-shows among these clients.

○ TESTIMONIALS

In most businesses that deal with the public, testimonials are an important marketing tool. This axiom certainly holds true for teen and senior pho-

tography. Most consumers want to feel comfortable with their buying decisions. Testimonials provide the potential client with the reassurance that other people have been satisfied with their experience and the product that the seller is providing. At our studio, we have a Thomas Kinkade guestbook in which the students write down their thoughts about their photographs and their overall experience at our studio. Most write two or three lines of lavish praise. This information is valuable because we can then quote them in the marketing pieces that we send to potential clients. We also ask the parents for their comments about the images and experience as well. Remember, with teen and senior photography, we are marketing both to the student and their parents. Parents want to know they can trust us. For too many years, disreputable photographers have done improper things with images or the child themselves. These horror stories make big headlines in the newspapers and on television. As professional photographers, we must continue to reassure these parents that the photo session will be conducted in a professional manner and that the photos will not be inappropriately used. The following letter is included with some of our senior mailings.

Our Seniors Tell Their Story Better than We Can!

"The pictures were awesome—I had a great time! Thank you for the great pictures and for your time in making my senior pictures sweet! I love my pictures."
—Toni Legati

"I had a great time getting my pictures done—they are fabulous! I appreciate the time taken to make my senior pictures great!"
—Christine Borowske

"I really enjoyed my time here taking my pictures with you guys. I really love my pictures—thanks again!"
—Ashley Norris

"The pictures that I had taken at Rice Photography were some of the best pictures that I have seen in a while. The care you took with my photographic experience was extraordinary. Thanks again!"
—Adam Kronenberger

"I had so much fun taking these photos—thank you so much for everything. I've never had a photo shoot like this. My pictures turned out great, and I can't wait to show my friends. Thanks again."
—Jennifer Holahan

"Great time! Lots of fun! It was something different than what I had expected of the experience."
—Colin Ladley

"The pictures turned out better than I would have ever imagined! I was impressed with how much time was taken for the photo shoot. I felt very comfortable, which helped in capturing my true self in the pictures. It will be hard to choose—they are all very good!"
—Ryan Jones

"I had a blast! They were so nice and very considerate. They understand I'm a teenager and didn't push me to hurry—and they let me do my own poses too! I loved my experience here and wouldn't choose anywhere else! Thanks, guys!"
—Whitney Brooks

"I really loved my pictures! I had a great time taking them, and I really enjoyed everything. You captured my real self."
—Jessica Gleba

O REFERRAL PROGRAM

Once you have photographed a high school senior or underclassman, you should work at getting that student to help you generate more sessions. There is no better advertising than a happy client. We created a system that rewards students who send other teens to our studio for a senior portrait session. We reward these happy clients by giving them something they always want—more wallet photos! We simply print

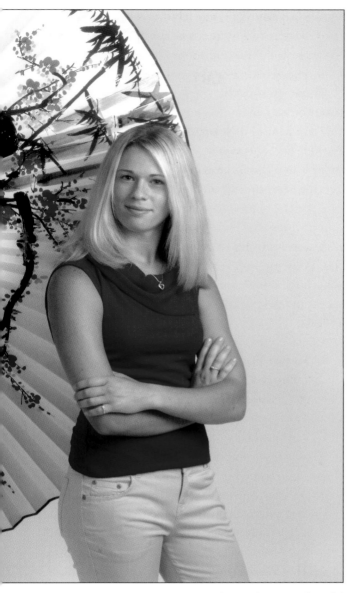 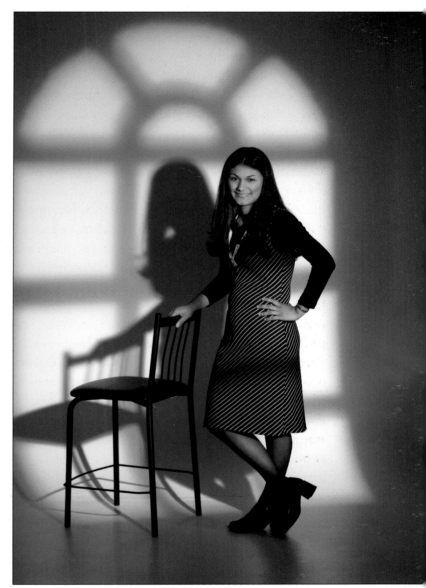

Running promotions that draw clients in during slower months will help take the pressure off of you during the hectic summer months. Images by Ken Holida.

the message below on card stock and hand a large quantity to each student we photograph. This simple reward program has proven to be very successful for our studio.

High School Senior Referral Bonus Plan
Receive 24 free wallet images*
for every new senior you refer to Rice Photography
who books a session!

*From a previously ordered image Offer expires December 31, 20XX.

○ THE VALUE OF PROFESSIONAL ASSOCIATIONS

I cannot stress enough how much professional associations have influenced my photography career. Wedding and Portrait Photographers International— WPPI (formerly WPI)—was the first professional association that I joined over twenty years ago. The knowledge that I gained from attending their conventions is immeasurable. The Professional Photographers of America (PPA) has also presented wonderful educational opportunities throughout my

photographic career. PPA affiliate organizations like the Professional Photographers of Ohio (PPO), Society of Northern Ohio Professional Photographers (SONOPP), Akron Society of Professional Photographers (ASPP), and the Photographic Art Specialists of Ohio (PASO) have all had a positive impact on my work, and I am proud to say that I had the opportunity to serve as president of each of these associations.

One such group is especially beneficial to senior portrait photographers. Senior Photographers International (SPI) is an organization that publishes newsletters and hosts a promotional materials exchange that has helped countless photographers to be more successful in this competitive field.

SPI also publishes newsletters for professional photographers. In each issue there are valuable articles and tips to help make members' studios more profitable. The newsletter also provides information on the group's exchange program, which allows each member to receive a hard copy of a mailing piece or even exchange price lists so that studio owners can compare notes on how they do business. Some of the best marketing ideas have since become widely used in the industry. A printed suggestion box included in the newsletter encourages members and viewers to make comments, both good and bad, to help strengthen an association.

SPI also offers a unique promotion to its members—their annual car giveaway. The way the program works is quite simple: studios can choose to participate in the car giveaway for only $100 per year. Each year, one studio is chosen, and the winning high school senior can choose between a new Ford Mustang, Chrysler PT Cruiser, or $20,000 in cash! SPI sends each participating studio promotional material to get the word out to clients about this unique prize giveaway. Many studios have found that the chance to win a new car has been the deciding factor for many seniors when they are selecting a photographer. A client of Ohio photographer Russ McLaughlin won this contest one year and Russ was able to garner a considerable amount of positive public relations. He contacted the school that the senior was from and was able to present the keys to the car in front of the entire student body. Needless to say, Russ booked a lot more sessions in that school after one of his seniors won a car!

Client Resources. SPI's website is also a great resource for clients. The site's home page emphasizes the importance of selecting a quality senior photographer and provides a directory that can lead prospective clients to your studio. Students can also get tips on choosing clothing as well as other helpful tips for the senior to consider when they make an appointment for their portrait session. The teens can also view samples of members' work, which boosts the photographer's visibility in their community, especially since membership is limited to one photographer per zip code. The letter to students reads as follows:

Senior Portraits: The Most Important Photos You Have Ever Had Taken

You have waited eleven long years for your turn, and it's finally here. You are a senior! One very important part of being a senior is having your senior portraits taken. We say that this is the most important portrait that you have ever had taken because this is the image that your friends and classmates will remember you by for many years to come.

Do you want to trust this important portrait to just any photographer? Of course you don't. That's why we have assembled the world's very best photographers who specialize in senior portraits right here on one website!

Take a look at the awesome senior portraits on our sample page and check out our suggestions of what to wear, and then search our directory to find the best photographers in your area.

Thanks for visiting!

Networking. All professional photographic associations are valuable because they allow you to get to know other photographers and learn from their experience in high-school senior photography. You would never meet many of these individuals on your own, because they don't work in your area or may be

By getting your images into the right students' hands, you can capitalize on one of the best marketing resources around—word of mouth. Images by Dennis Valentine.

among your competition. Fair competition is healthy, and all photographers should work to have a good relationship with each other. You never know when you might need another photographer's help.

Print Competition. All professional photographic associations also have print competitions. Over the years, many people have asked, "Why should photographers enter competition?" There are many, many reasons why; I will highlight just a few. Competition brings out the best in the participants. People have a natural tendency to try to achieve greater success when their efforts are being measured in some way. Photography is no different. When a photographer enters a print competition, he is having his images judged by a panel of experts. Those judges are looking to reward exceptional artistry and to point out any flaws in the submitted images. Through their scores and critiques, the judges help to educate the photographer.

It is this very process that can help you to become a better photographer. How, you may ask? Well,

when you present your image, the judges may find a very small flaw that you never noticed. It is the judges' role to closely study everything about each image and then score the print. Once any flaws are pointed out, you will be more aware of these problem areas in future submissions. The next time you are in a similar situation, you will remember the judges' comments and correct the flaw before you take the photograph. You will begin to pay much more attention to even the smallest details, and you will give your clients a product that is far superior to the portraits you created before you began entering competition. In time, you create a win/win situation—you receive higher print scores and your clients receive better quality images from your studio.

A second reason to enter print competition is for peer recognition. Many industries reward the best in their field, and photography is no different. Respect from your fellow photographers is very gratifying, and it will encourage you to continue to achieve even more success. As your success grows, you will be

asked to help others just beginning in competition. Your advice will help them become better image-makers. In effect, you will be raising the bar for professional photographers throughout the industry.

Professional organizations award their members for overall accomplishments in the field of photography and for the success of their images in print competition. Receiving ribbons and awards in any field is indeed newsworthy and, accordingly, many photog-

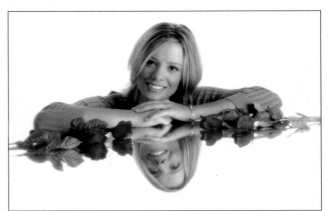

Images by Ken Holida.

Don't underestimate the importance of joining professional associations. They will help you to grow professionally and to network with other photographers. Image by Monte Zucker.

raphers write and send out press releases to local newspapers to announce their success. These releases often appear in the business section—and though this type of "advertising" won't cost you a cent, some argue that it's the best form of marketing around. To consumers, a press release announcing that a photographer won an award for their photography is more convincing than an ad for that same studio. Consumers see competitions as unbiased comparisons of products—or individuals—in the same field, so informing them about your success will increase your studio's appeal. A sample press release follows.

FOR IMMEDIATE RELEASE

Rice Photography Sweeps Competition

At the recently completed folio competition hosted by the Society of Northern Ohio Professional Photographers, photographers from Rice Photography in North Olmsted took the top honors. Barbara Rice had the highest-scoring portfolio and received Best of Show honors while Travis Hill came in Second Place and Patrick Rice took Third Place.

This marks the first time that one studio took the three top honors in the portfolio competition. The Society of Northern Ohio Professional Photographers is an association of the finest photographers in Northern Ohio. The society recently celebrated its fiftieth year of serving the professional photographers of the area.

The Senior System: Ten Small Steps for Big Results

by Michael Ayers

I am not a senior photographer! These are the words I spoke to clients for years because I didn't want to be involved with giving up my evenings and weekends to photograph at school functions. However, the effects of advertising that I did not create senior portraits were devastating to our business! True, it is important to specialize in a specific field of photography, but by not allowing any senior clients through the door, I was losing income in the days between wedding sessions and was not capitalizing on future family portrait sessions and additional weddings in the future!

One thing I learned in photography school two decades ago that had a deep impact on me was to never run my studio like any other. If another photographer has a service just like mine, I have to change mine to something different and better. Years of marketing research have taught us that the company that stays on top does so because they are always one step ahead of the competition. Innovation and customer care, not lowest prices, will keep people coming back. So with this in mind, I set out to construct a whole new way of marketing to seniors and photographing them.

Since budgets are limited and marketing is expensive, I tried to find the very best way to bring in new faces without using traditional forms of paid advertising. Kids these days talk to each other about their portraits; when one student tells another that she had a great time at our studio and shows off our work, the prospective client begins to strongly consider our studio. Anything we can do to start this process rolling in our direction is a good thing. Before too long we have them lining up at the door!

After analyzing what we have done correctly, we found that there are ten major things that we started doing that have made a significant impact on our senior sales. The results have been awesome! Recently, we received a senior order totaling $1,100. My wife, Pam, was very excited, as any photographer might be due to the fact that most average senior

Above—Personalizing your images for your clients can mean big sales. This teen was known to always carry Chapstick—so photographer Michael Ayers capitalized on that fact to create this fun-filled image. *Facing Page*—Stand-out photos like this can help you to boost your sales averages. Image by Michael Ayers.

orders across the country range from about $350 to $650. But this was a special day at Ayers Studios because I had just figured our senior sales average for the last thirty seniors during the past three months. The result was a whopping $1,478 per senior over this time period! I had to inform my wife that the order we received on that day was actually *hurting* our average! Unbelievable! Sure, we have had some orders on the extreme side: one was over $4,000 and one was about $650, but nearly every senior's mom eventually swipes her credit card for about $1,500!

Here is our studio's ten-step senior action plan:

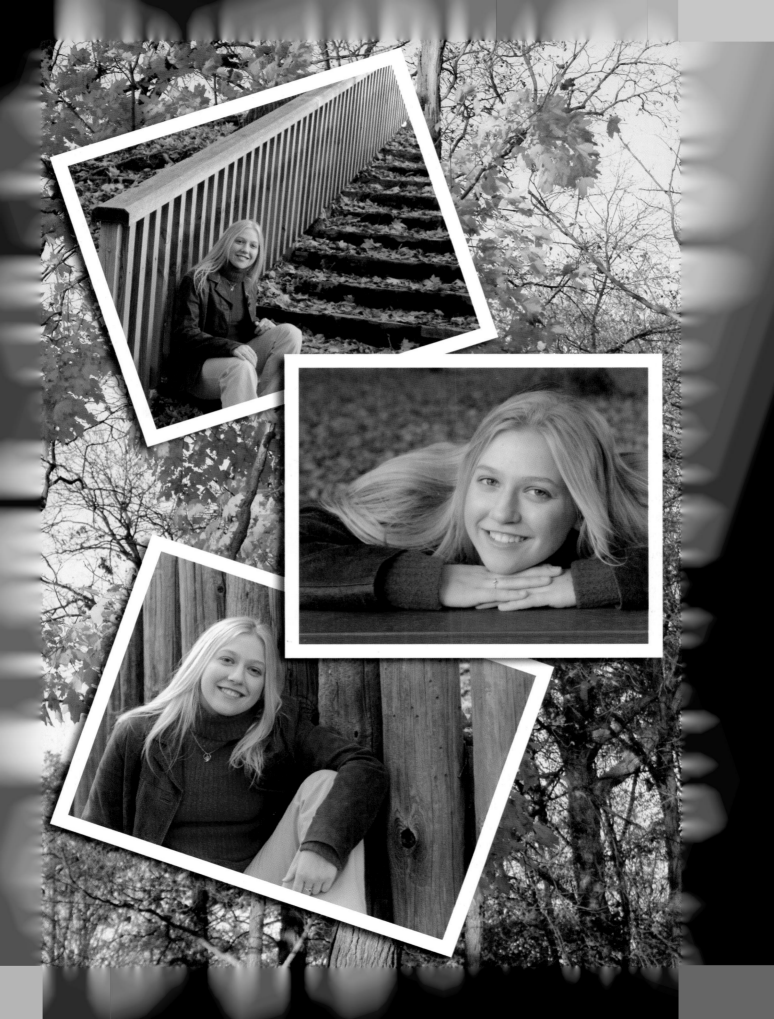

1. *Giving great customer service, plain and simple.* Not satisfied? Tell us, and I will personally make it right! There is no complaint box at Ayers Studios because any problem gets fixed immediately. I have always believed that this is one area where photographers are lacking: our guarantee means 100 percent satisfaction. Statistically, an unhappy client will tell potentially dozens of other future customers, but have you ever had an unhappy buyer with whom you fixed all their concerns? This person soon becomes your best friend!

2. *Charging a significant session fee and deposit up front!* Money spent is money forgotten. And you must charge what you are worth—this includes session fees! I have started getting a significant senior session fee and a big juicy deposit to go with it. At Ayers Studios, we just collect a deposit, not a minimum purchase. Therefore, if they don't use all of this amount, they can get a refund, but that never happens. For me, this takes the pres-

sure off the client to spend a minimum, but I have met several great image-makers that are highly successful using minimum purchases—just get a big check in advance!

3. *Creating special montages and collages to set our images apart from the competition.* This is the most visible change in our senior system. I am having the time of my life creating layered composites and custom montages for these kids! The PR from this alone drives the whole senior marketing process! Whenever we allow one of our Premiere Albums out of the studio, we tend to get more phone calls from new seniors or their parents. A Premiere Album, more unique than a proof book, has several special full-sized 10 x 13-inch pages with collages displayed.

4. *Using our spectacular Million-Dollar Price List.* In 1996 we made the ultimate order form, which included all sizes of folios and a total à la carte photography plan. Folio sales from General

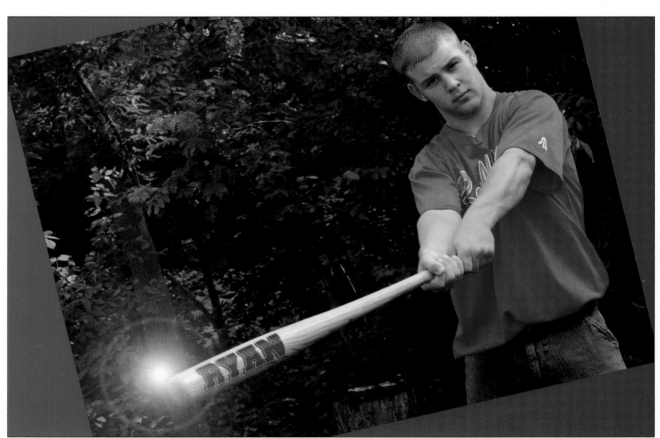

Image by Michael Ayers.

Products have grown exponentially, and our seniors' moms couldn't be happier that they can order whatever they like using a simple order form and price list. Our little mom-and-pop studio set a five-year goal for generating one million dollars using this new price list; we did it in just over four.

5. *Allowing clients to order from any pose, in any size, and in any quantity with StudioMaster Pro.* No more packages! Our clients appreciate the fact that they can order only what they want and not pay for things they don't need. But amazingly, it usually turns into a shopping spree most of the time because customers tend to order more, even though they don't have to. The pressure is off, but we are here to help and make suggestions where necessary. Our clients come to me for advice like a trusted friend, not a salesman.

6. *Selling lots of General Products folios to our clients (and not pushing giant wall-portrait sales).* Yes, we create lots of wall portraits for the moms who are sending their babies off to college. A 16 x 20-inch print on the wall, preferably on canvas, is a great sales booster. But we have folios from General Products displayed on our order form, and there are stacks of them going out the door with every order. A large folio sells for about the same price as a moderately sized wall portrait, and I never seem to invoice more than just one wall portrait per order, but there is no limit to the folio sales for special relatives!

7. *Putting senior photographs online for their friends to see using Eventpix.com.* The greatest thing since right turns at a red light! We use Eventpix.com two different ways to help build our senior business. First, I place senior proofs online for family, neighbors, and especially other seniors to view. As a member of WPPI or PPA, with an annual maintenance fee, I can upload as many as forty images from a session for just $10! Second, I get permission to place my Greatest Hits up on the website for any prospective senior to see; every student's parent signs a model release, and their best images get placed onto a special link on www.TheAyers.com—Password: Seniors. Check it out!

8. *Using StudioMaster Pro software to FTP all our orders to H&H Color Lab with incredible speed.* With DSL or a cable modem, photographers can now send all their orders directly to the lab without shipping anything. We have the images back in a matter of a few days, or even as few as twenty-four hours if we are in a rush. This has been the handiest little idea for a studio–lab interface that I have ever seen. In reality, using Fujifilm's StudioMaster Pro software and H&H Color Lab's FTP site, I can in effect print my own images on one of Fujifilm's Frontier printers on gorgeous Crystal Archive paper. Why try to run my own processing lab when I can almost print all my work with the click of a mouse?

9. *Asking seniors to show their images to friends wins instant referrals!* We don't collect the names of referrals from our student clients—we don't need to! We simply ask them to help us out by showing our spectacular work to all their friends—and they always do. We have thought about having senior class reps at every school, but we don't have contracts with any schools. High schools in our area are very territorial and do not share any information; they frown upon solicitation within school walls—plus we don't want the headaches associated with pandering to the contracted school's needs.

10. *But, most importantly, we create a spectacular General Products Premiere Album to show our clients all their proofs!* We don't have proof books or proof folios here at Ayers Studios, but that is what every other studio in town gives to the students. We use the General Products Digital Showcase Album (model DS), a ring-bound album that we co-designed to showcase 10 x 13-inch prints. When opened, these Premiere Albums, as we call them, gather all the attention of a big food fight in the school cafeteria! Everyone wants to see what unfolds.

Left—Image by Michael Ayers. **Above**—*The Ayers Studio often creates promo magnets to give to targeted students, like the homecoming queen or the football team captain.* **Facing Page**—*This collage shows many aspects of this senior's personality. Image by Michael Ayers.*

posed to a staple item), we need to ensure our clients' satisfaction . . . nothing but the best!

Another interesting product that we have started creating for seniors are wallet magnets. If a senior student wants us to, we'll stick magnetic strips on the back of wallet photographs so they can give away photographs that can be put up in their friends' lockers. Of course, we often create "promotion" wallet magnets to give to targeted students, like the homecoming queen or the football team captain. Who better to give away freebies than the kid that the whole class looks up to?

The other approach that has been extremely successful is our Senior Album program! Using the student's favorite proofs, I create special albums that show their life at this moment. Why create spectacular albums for just weddings? These books instantly add over $1000 to a senior order—sometimes much, much more! These custom albums can resemble a medium-sized wedding album or may be more like coffee-table books. The seniors' moms are the target market for these, and the parents who can afford it are ready to sink at least $1000 into this emotional decision.

So we are really looking forward to this year's season with our new senior system. We will be the area's coolest senior photographer! Try a few of our ideas, and your studio will also be creating senior portraits in a class by themselves!

So, the senior business is alive and well in this area, even though a couple of other established senior portrait businesses recently went out of business. I've found that the clear reasons for our success over the competition exist in just three areas: outstanding service, exceptional creativity, and unparalleled quality. In this day and age of questionable economy (especially as we market a "luxury" product as op-

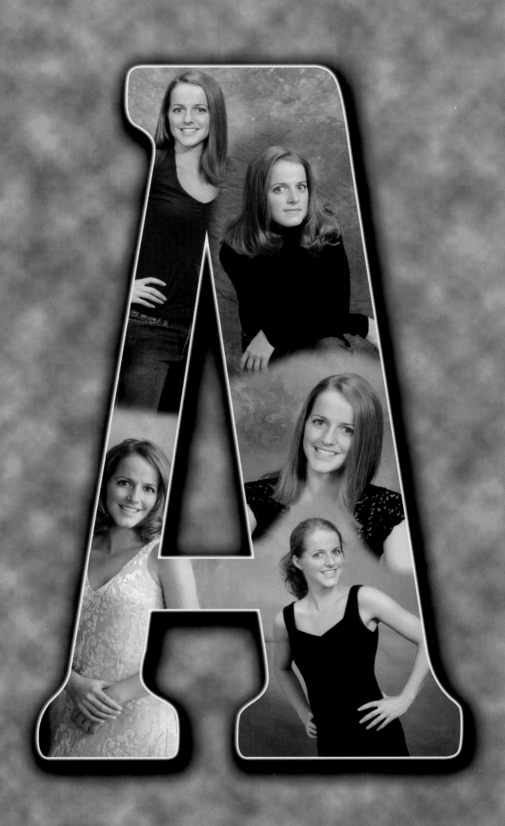

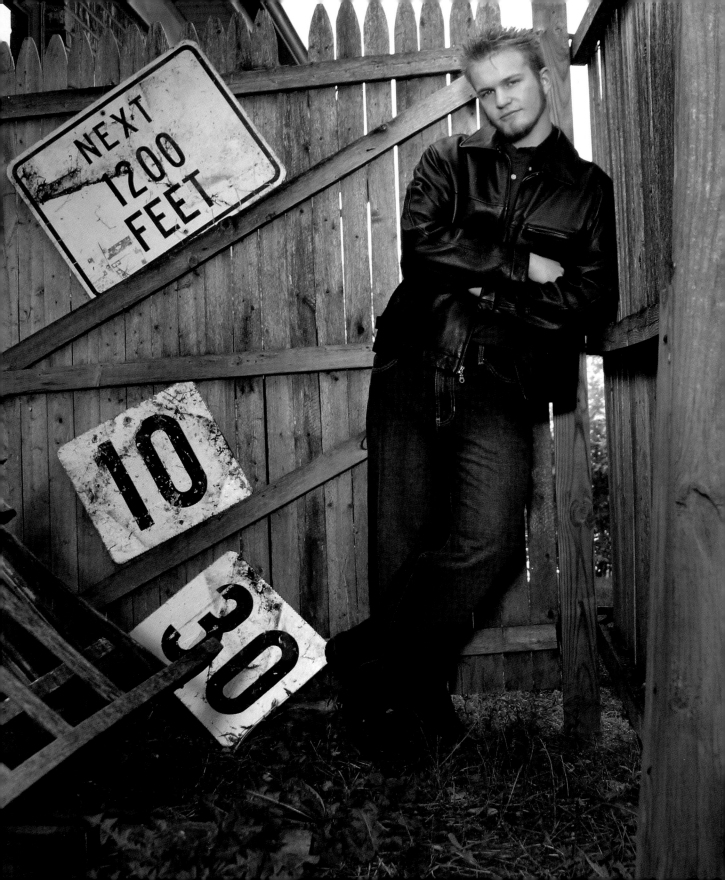

Proofing and Copyright Issues

Once the session is finished, the digital photographer's job is far from finished. In fact, the way in which you proof your images is an important part of the senior portrait photography process.

◯ DIGITAL PROOFING

With the advent of digital capture, the photographer now has several choices in the area of digital proofing. Of course, the studio can still have their color lab make 4 x 5- or 4 x 6-inch traditional paper proofs. This is what our studio still for most of our senior photography. The reason we have maintained traditional paper proofs is very simple—this has allowed a very smooth transition for our customers from film capture to digital capture. Many senior portrait clients are uneasy with the notion of not receiving actual photographs to view and order from. By continuing to provide paper proofs, we can assure the clients that digital photography is just a means of image capture and does not impact what they receive from the studio. This puts the student's mind at ease and has made them more accepting of the technology.

For the studio, traditional paper proofs are a very inexpensive option. With many color labs, discount, and department stores making 4 x 6-inch proofs for 20 cents or less each, it is easy to build the small cost into the package. If the paper proofs that we are having printed are not being placed into a folio or the General Products' Ellie Vayo Senior Yearbook, we will have the word "proof" overlaid onto each image. (This is a simple text layer that

Facing Page—Image by Kathryn Sommers. **Above—***These cards are mailed to clients after their session. Promotional materials by Rice Photography.*

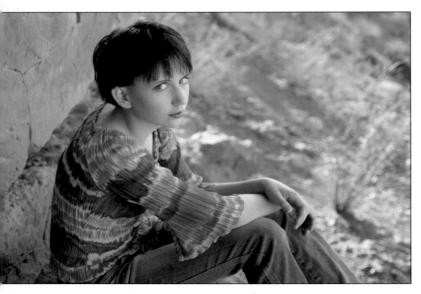

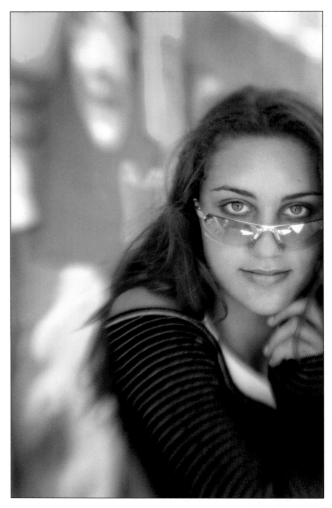

It's easier than ever for clients to copy your images, and this will cut into your profits. Take the measures outlined in this chapter to safeguard your work. Images by Lisa Smith.

we add in Photoshop.) All photographers should be aware of the ease of illegal copying of their images. It is difficult to copy images that are in folios or albums, but loose prints can be easily copied.

When using traditional paper proofing methods, many studios have chosen to create digital contact sheets containing 4, 6, 9, 12, 16, or more images per page. These contact sheets provide a means for the client to view a rendering of the image for selection purposes. While most studios make their contact sheets on photo quality paper, I have seen some studios just use regular copier paper. Many studios will overlay their studio name or logo onto the images so that the client does not simply cut up the contact sheet and use the prints as finished images. Many album companies now offer three-ring binders to accommodate digital contact sheets. These provide a professional appearance for the image presentation.

Online proofing is yet another option for today's photographers. We offer online proofing of high school seniors and other events in addition to paper proofing. Eventpix.com is our choice for online proofing. They host the images for a period of up to sixty days, and we have the option of extending that for a nominal fee. Unlike other online hosting com-

panies, Eventpix.com does not take a percentage of each sale. All orders are forwarded directly to our studio, and all credit card information is secure. They even calculate shipping and sales tax. It couldn't be easier for the photographer. We chose to use this service because we determine who makes our prints. Some twenty-five plus color labs are now directly involved with Eventpix.com, with more labs scheduled to join. Many of these online posting companies handle the entire transaction and make the prints. We were concerned over the consistency in color balance and image quality. We want all of our images to be printed from the same source.

Still other photography studios offer video proofing for their clients. This type of proofing has been popular for many years since many of the video cameras can create a positive image from film negatives. It was very easy for studios to create a video proof

book for the clients by simply processing the film and using a Photovix or similar viewing device. Creating video, CD, or DVD movies of a client's images can save the studio the expense of proofing and guard against illegal copying of the images. There are many software programs available for CD albums. We have used FlipAlbum because of its simplicity for both the client and our studio.

O UNAUTHORIZED IMAGE REPRODUCTION

Self-serve color copiers and home scanners have made copying professional photographs very easy for the unscrupulous consumer. This problem has plagued photographers for years, and what to do about it has been a hotly debated topic.

In an attempt to ensure that the client places an order with the photographer rather than simply scanning and reproducing their proofs, many photographers have simply chosen to not allow proofs to leave the studio. I see two problems with this decision. First, it is beneficial to the studio for the senior to show off their portraits to as many of their friends

as possible to help generate referrals. The second problem is that at some point, the studio has to deliver finished prints to the client. Once a dishonest client has one good image from their session, the studio no longer has control over the reproduction of that image.

In our studio, we have done several things to discourage the unauthorized duplication of our portraits. Senior portraits can be presented to the client in one of several ways. We sometimes place their images in a 10 x 10-inch folio with the portraits mounted in mats, four per page. These images cannot be removed from the folio, so the entire presentation would have to be placed onto the copier or scanner to make copies. The folio matting keeps the print from laying flush on the copier surface and thus degrades the quality of the copy or scan. We also use General Products' Ellie Vayo Senior Yearbook to present images to our students. Again, the images cannot be removed from the matting in this book-style presentation. Any loose proofs that we allow the students to take home always have the word

Many photographers no longer allow proofs to leave the studio—at least not without first securing a substantial deposit. Images by Patrick Rice.

"proof" in large letters across the bottom of the image. We simply make a layer in Photoshop and apply it to each image. As mentioned earlier, we also post our images on the Internet via the website eventpix.com. With eventpix.com, we can choose to watermark all of our images to discourage copying.

It has long been our policy to try to discourage the unauthorized copying of our photographs through the literature we present to each client. The following information sheet goes out with every portrait order.

Important Notice
About Copyright Protection

The U.S. Copyright Act protects photographers and other creative artists by giving the author of any photograph the exclusive right to reproduce your photographs. This includes the right to control the making of copies in any form.

It is illegal to copy or reproduce these photographs yourself or elsewhere without our written permission, and violators of this federal law will be subject to its civil and criminal penalties.

We are certified members of the Professional Photographers of America and the Professional Photographers of Ohio, both of which monitor copyright violations. To place an order, call 440-979-0770 or visit us on the web at www.ricephoto.com.

—Rice Photography

Some photographers, like Jim Williams and Ellie Vayo, personally add perforated sheets to their albums that outline their rights to their images. Other photographers mail a statement about copyright issues to their clients. Photographer Russ McLaughlin words his this way:

Copyright Agreement

In 1976, the federal government passed a law making it illegal to copy materials protected by a copyright. These materials include items such as sheet music, books, paintings, and professionally created photographs.

The portraits you will commission us to create are made by the finest craftsmen in the industry. Our stu-

Image by Visualizations.

dio invests heavily in training and education to provide the highest-quality photography found anywhere—and this high quality found in each of your portraits cannot be duplicated or copied without suffering severe loss of sharpness, color, and clarity. We also find copying morally wrong as it denies us our rightful income—the fruits of our labor and God-given talents.

Since such a loss would reflect poorly on the reputation of our work, McLaughlin Studios has reserved the copyright on every negative to ensure that additional images can be made to our exact specifications.

To ensure the integrity of our images and to make sure everyone understands our position on the copyright issues, all clients are required to sign a copyright agreement before any images leave the studio. We thank you in advance for your cooperation. If you are unwilling to sign our copyright agreement, we will not be able to create our images for you.

I feel Russ handles this issue very nicely in a straight-forward, easy-to-understand manner. He is very firm in his policies but tempers that firmness with a call to morality. He effectively tries to make the client feel guilty for breaking the law and his policies.

Closing Thoughts

I want to thank everyone who contributed text and/or images to my book. This book would not be possible without them. These individuals are wonderful artists and marketers, but there are many others, whose names appear below, who have inspired me as well.

I would like to thank the many photographers who have helped my teen and senior business grow and prosper. Larry Peters has always been a friend and mentor who was willing to share his vast knowledge and experience whenever I asked. The industry "king of senior photography," Larry has done more for the advancement of senior photography than any other photographer. Joe Craig has also been an important influence in this competitive field. John Hartman is one of the greatest marketing men in the senior portrait business. He has helped thousands of photographers make more money. Other influential teen and senior photographers include Steve Ahrens, Craig Kienast, Fuzzy Duenkel, Jeff Smith, Ralph Romaguera, and Tim Kelly. Of course, I need to thank some of the best teen and senior portrait photographers in Ohio: Jim Williams, Russ McLaughlin, Ellie Vayo, Robert Williams, Robert Senn, and many others. All of these men and women have paved the way for photographers across the country and beyond to be successful in this business. It is this sharing of ideas and information that makes photography an honorable profession—one that I am proud to be a part of!

I hope this book has inspired you to grow your teen and senior photography business. Best of luck!

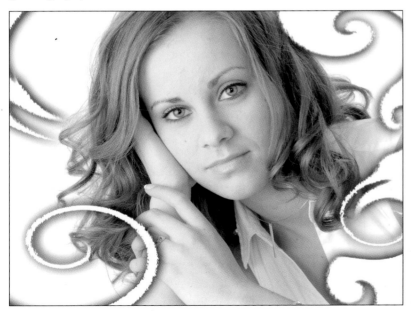

Image by Visualizations.

SUPPLIER DIRECTORY

The following list provides contact information for the photographic products and services discussed in this book, plus other helpful resources for teen and senior photographers.

- **ABC Pictures**—black & white and color marketing pieces; www.abcpictures.com
- **Adobe**—Photoshop, Photoshop Elements, InDesign; www.adobe.com
- **American Photographic Resources**—backgrounds and props; www.aprprops.com
- **American Student List**—high-school senior mailing lists; www.studentlist.com
- **Anderson's School Spirit**—backgrounds, props, prom and dance supplies; www.andersonsspirit.com
- **Backdrop Outlet**—backgrounds and props; 800-466-1755
- **Bannister Designs, Inc.**—signs and license plates; www.engravenet.com
- **Blossom Publishing**—marketing pieces and mailers; www.blossom-publishing.com
- **Bogen Imaging**—photographic equipment, accessories; www.bogenphoto.com
- **Buckeye Color Lab**—lab services; www.buckeyecolor.com
- **Canon USA**—digital cameras and flash equipment; www.usa.canon.com
- **Cole and Company**—backgrounds, frames, albums; www.coleandcompany.com
- **Corel**—Corel Painter; www.corel.com
- **Custom Brackets**—camera brackets; www.custombrackets.com
- **Denny Manufacturing**—backgrounds and props; www.dennymfg.com
- **Esther Beitzel Backgrounds**—backgrounds; www.photobackgrounds.com
- **Eventpix.com**—online viewing and ordering of images
- **Excel Picture Frames**—photographic frames and frame bags; www.excelpictureframes.com
- **ExpoDisc**—white balance filter; www.expodisc.com
- **Flower Factory Inc.**—silk flowers, miscellaneous props and supplies; www.flowerfactory.com
- **Fujifilm USA**—digital cameras, StudioMaster Pro; www.fujifilm.com
- **General Products**—the Ellie Vayo Senior Yearbook, folios; 800-888-1934; www.gpalbums.com
- **H&H Color Lab**—lab services; www.hhcolorlab.com
- **Ikea**—props; www.ikea.com
- **Knowledge Backgrounds**—backgrounds; 888-849-7352; www.handpaintedbackgrounds.com
- **Lens Babies**—special effects lenses; www.lensbabies.com
- **Les Brandt Backgrounds**—backgrounds; www.lesbrandtbackgrounds.com
- **Lindahl**—lens shades, vignettes, filters, flash brackets; www.photo-control.com
- **The MAC Group**—cameras, meters, lighting, radio slaves, camera bags, digital backs, monitor calibration systems; www.MACgroupUS.com
- **Marathon Press**—marketing pieces and mailers; www.marathonpress.com
- **National Direct Marketing**—high-school senior mailing lists; 800-870-4358; www.ndmservices.com
- **NEO Digital Imaging**—lab services; www.neoimaging.com
- **Ontrax Systems**—background support system, backgrounds, props; 800-598-4008
- **Photo Showcase**—backgrounds and props; 336-229-9910
- **Pierce Company**—studio supplies and props; 800-338-9801; www.thepierceco.com
- **Profoto: The Light-Shaping Company**—studio lighting; 914-347-3300
- **Tallyn's Professional Photographic Supply of Peoria**—photo and lighting equipment, recovery services; 800-433-8685; www.tallyns.com
- **Thrifty Signs**—license plates and signs; www.thriftysigns.com
- **Winona Printing Company**—marketing pieces and mailers; 800-454-5743
- **Zreiss**—cameras, lenses, memory cards, and photographic accessories; www.zreiss.com

INDEX

GROUP PORTRAIT PHOTOGRAPHY HANDBOOK,
2nd Ed.

Bill Hurter

Featuring over 100 images by top photographers, this book offers practical techniques for composing, lighting, and posing group portraits—whether in the studio or on location. $34.95 list, 8½x11, 128p, 120 color photos, order no. 1740.

THE ART AND BUSINESS OF
HIGH SCHOOL SENIOR PORTRAIT PHOTOGRAPHY

Ellie Vayo

Learn the techniques that have made Ellie Vayo's studio one of the most profitable senior portrait businesses in the U.S. $29.95 list, 8½x11, 128p, 100 color photos, order no. 1743.

THE BEST OF WEDDING PHOTOGRAPHY, 2nd Ed.

Bill Hurter

Learn how the top wedding photographers in the industry transform special moments into lasting romantic treasures with the posing, lighting, album design, and customer service pointers found in this book. $34.95 list, 8½x11, 128p, 150 color photos, order no. 1747.

THE BEST OF PORTRAIT PHOTOGRAPHY

Bill Hurter

View outstanding images from top professionals and learn how they create their masterful images. Includes techniques for classic and contemporary portraits. $29.95 list, 8½x11, 128p, 200 color photos, index, order no. 1760.

THE BEST OF TEEN AND SENIOR PORTRAIT PHOTOGRAPHY

Bill Hurter

Learn how top professionals create stunning images that capture the personality of their teen and senior subjects. $29.95 list, 8½x11, 128p, 150 color photos, index, order no. 1766.

PLUG-INS FOR ADOBE® PHOTOSHOP®
A GUIDE FOR PHOTOGRAPHERS

Jack and Sue Drafahl

Supercharge your creativity and mastery over your photography with Photoshop and the tools outlined in this book. $29.95 list, 8½x11, 128p, 175 color photos, index, order no. 1781.

POSING FOR PORTRAIT PHOTOGRAPHY
A HEAD-TO-TOE GUIDE

Jeff Smith

Author Jeff Smith teaches surefire techniques for fine-tuning every aspect of the pose for the most flattering results. $29.95 list, 8½x11, 128p, 150 color photos, index, order no. 1786.

LIGHTING TECHNIQUES FOR
FASHION AND GLAMOUR PHOTOGRAPHY

Stephen A. Dantzig, PsyD.

In fashion and glamour photography, light is the key to producing images with impact. With these techniques, you'll be primed for success! $29.95 list, 8½x11, 128p, over 200 color images, index, order no. 1795.

PROFITABLE PORTRAITS
THE PHOTOGRAPHER'S GUIDE TO CREATING PORTRAITS THAT SELL

Jeff Smith

Learn how to design images that are precisely tailored to your clients' tastes—portraits that will practically sell themselves! $29.95 list, 8½x11, 128p, 100 color photos, index, order no. 1797.